IMAGES
of America

SYRACUSE

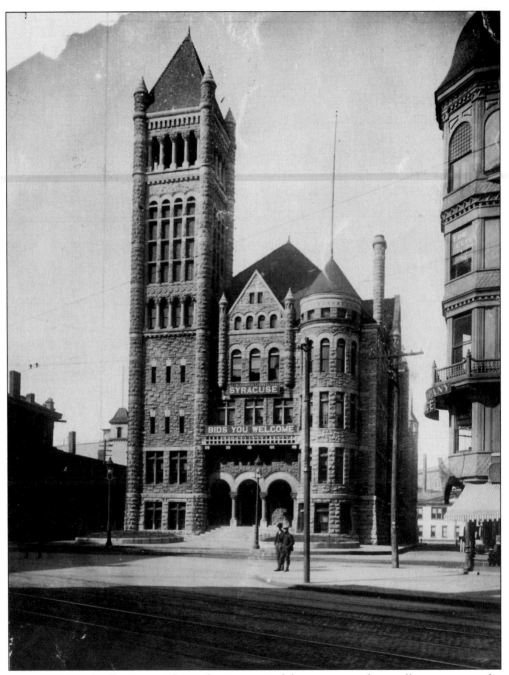

Syracuse City Hall, 1911. The arches, rusticated limestone, and overall impression of a medieval castle reflect this structure's creation in 1889, during the era of Richardsonian Romanesque architecture. The welcome sign was intended for the thousands of visitors who arrived in the city on the New York Central Railroad. Its main tracks passed directly in front of the building for over forty-five years.

IMAGES
of America

SYRACUSE

Onondaga Historical Association

Text by Dennis J. Connors

ARCADIA

First published 1997
Copyright © Onondaga Historical Association, 1997

ISBN 0-7524-0551-9

Published by Arcadia Publishing,
an imprint of the Chalford Publishing Corporation,
One Washington Center, Dover, New Hampshire 03820.
Printed in Great Britain

Library of Congress Cataloging-in-Publication Data applied for

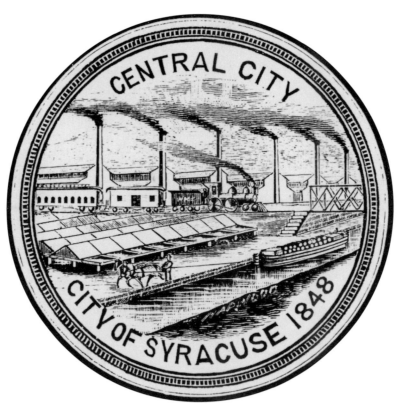

Official Seal of the City of Syracuse.
This publication is a Syracuse Sesquicentennial project.

Contents

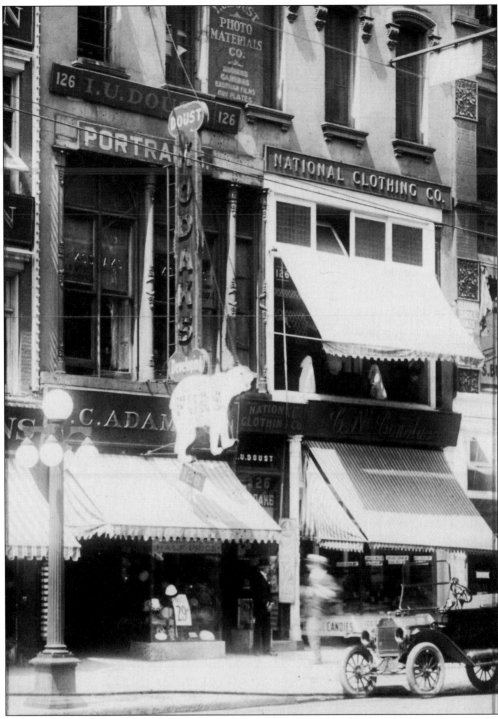

Doust Studios at 126 South Salina Street, c. 1915. Photography reached Syracuse in the 1840s. By 1851, daguerreotype galleries were operating in the Hanover Square area. Syracusan Isaac Uriah Doust entered the field in 1875. In the 1890s, he moved his studio to this building, and his business expanded to include cameras and supplies for the amateur photographer.

Introduction

Most everyone enjoys looking at old photographs. They are like little time machines, allowing us for a few moments to journey into the past. Interestingly, along the way, everyone seems to make different observations. Some might focus on the fashions of the day, while others re-discover a community's long missing architecture. Many may notice how past lifestyles are radically different from ours today, while a few of us find the constants, activities that link us to our ancestors. In the process, a little perspective settles in. We become aware that we fit into a continuum of human existence. We are not the first to walk here, and we will not be the last.

The Onondaga Historical Association (OHA) serves as the primary history center for the Greater Syracuse community. OHA's archival and museum holdings number over one million items. These are preserved and made accessible to the public through the OHA's Research Center and Museum, both located in downtown Syracuse.

Photography arrived in Syracuse in the 1840s. OHA has been around almost as long, having been founded in 1862. Over its decades of existence, OHA has amassed what undoubtedly is the largest single collection of local historical photographs in the region, numbering over 50,000 images. There are numerous views of Syracuse and Onondaga County subjects located in OHA's Research Center holdings that are found nowhere else. These collections also include original daguerreotypes that record the earliest photographic images of the city. It is a significant resource and forms one of the community's most fundamental records about itself. It allows Syracuse and Onondaga County to define their very identities.

The photography holdings are also extensively used, in more practical ways, by hundreds of individuals annually. For example, engineers refer to them in preparing environmental impact statements, architects scan the images for clues to missing details in building restoration projects, and teachers explore the photos for scenes that will illuminate a school curriculum.

Syracuse was incorporated as a city in 1848, and this book was prepared on the eve of its sesquicentennial. It is intended, in part, as a commemoration of that anniversary. It will also serve as a ready guide to a cross-section of available images that can be reproduced for other projects. Most importantly, it will offer everyone an opportunity to experience a sizable and profound selection from OHA's photo collection in a single publication.

This book is not intended as a chronological narrative of Syracuse history. Others have produced those before. It is an admittedly personal selection of images, with brief observations, presented for readers to discover at their leisure. Of course, while enjoying the images, one might possibly come away knowing a bit more about Syracuse's past than when they began.

Because of the size and scope of OHA's photographic collection, it was decided to limit this publication to just images of Syracuse. OHA's photo resources are sufficient to produce further titles relating to Onondaga County's numerous towns and villages, and that possibility is under consideration.

Syracuse, like many cities, owes its existence to the combination of a marketable local natural resource, salt, with a location astride a major transportation network, first the canals and then the railroads. These factors laid the city's economic foundations in the early nineteenth century. The importance of salt declined following the Civil War, but by then a concentration of local wealth, entrepreneurship, and inventiveness led to the establishment of numerous industries. They, in turn, were ready to employ the century's influx of immigrants. The city steadily expanded, reaching a peak population of 220,000 in 1950. Syracuse University, founded in 1870, grew to be a significant employer and a major factor in the dynamics of community identity and life.

Since World War II, much of the heavy industry has shifted away, replaced with a greater variety of smaller service and technical businesses. The population of the city has declined as suburban growth soared, and it has become more ethnically diverse, as people migrate from other regions of the nation and the world. Syracuse remains the third largest city in upstate New York and the cultural and economic hub of central New York.

Selecting the actual photos for this book was a formidable but rewarding process. Some pictures are classic scenes. Although published elsewhere before, it would be unfortunate to omit them. An overall effort was made, however, to emphasize the inclusion of a number of images that have rarely, if ever, appeared before in print.

The views in this book are organized into six chapters. The first one samples Syracuse's urban landscape and how it has evolved over time. Chapter Two provides a look into some of the occupations that have engaged our citizens in times past. It is followed by a section that offers an exploration of various human events, small and large, many of which we still emotionally share with past generations. Chapter Four reminds us that tens of thousands of individuals have called Syracuse home over the last 150 years. Each is forever a part of its heritage, contributing in countless ways to both its diversity and collective strength.

Chapter Five is a tribute, of sorts, to three of the most distinctive historic features of Syracuse's growth. The presence of its salt industry and the downtown routes of the Erie Canal and the railroad lines strongly shaped the city, physically and visually. Their impact was so significant that all three still form the graphic image on the official city seal.

Although the book's first chapter, alone, demonstrates how remarkably the city has changed over time, Chapter Six especially showcases some of the architecture that has been lost in the process. Its point is not to criticize or bemoan the losses. Rather, the final chapter seeks to offer perspective. By seeing how much has disappeared, it becomes clearer that there is a unique value and precious nature to the relatively small percentage of historic architecture that has survived. Our generation and our children's can enjoy these tangible connections to our heritage, if we take time to protect them. Once gone, they are lost forever. Indifference should not guide the future for those that remain.

This book would not have been possible without the efforts of the many individuals who have taken the time to save and donate these photographs to the OHA over many decades. Additionally, Richard N. Wright, past OHA president, and other volunteers and staff worked tirelessly for years to insure that these images were identified, organized, and copied.

My work on this publication was aided immeasurably by Judy Haven of the OHA Research Center staff. I also wish to thank Gregory Daily and Ellen Schwartz of the OHA Museum staff, Barbara Rivette of the Board of Directors, and Henry Schramm for helpful comments and suggestions.

Dennis J. Connors
Syracuse, New York
July 1997

One
Places in Time:
A Landscape of Change

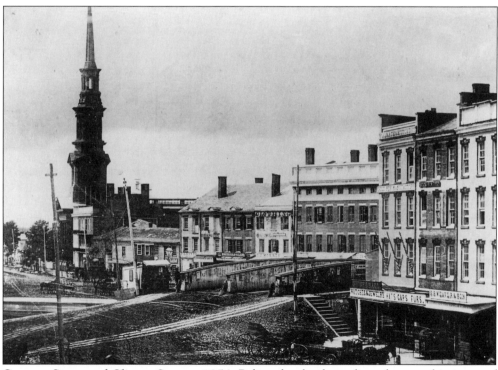

Genesee Street and Clinton Square, 1854. Believed to be the earliest photographic image of Syracuse, this scene was captured by local photographer George N. Barnard (see page 79). The Gridley Building was built where the row of three buildings stands on the right. Salina Street is ramped to bridge over the Erie Canal. The First Baptist Church is seen in the background.

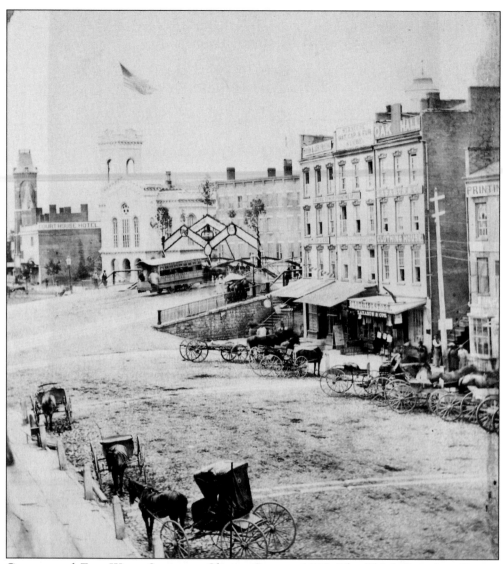

Genesee and East Water Streets at Clinton Square, 1865. The Third Onondaga County Courthouse, not yet ten years old, stands prominently on the north side of the square. The welcome arch, erected to greet returning Civil War veterans, spans Salina Street, and a horse-drawn trolley of the Central City Railway passes beneath it. Note the stone hitching posts that line the edge of Genesee Street.

Gridley Building, c. 1870.
This rare view shows the
Onondaga County Savings
Bank Building of 1867,
before it was extended to
the east with an 1875
addition. It was renamed
the Gridley in 1899 when
the bank moved across
Water Street.

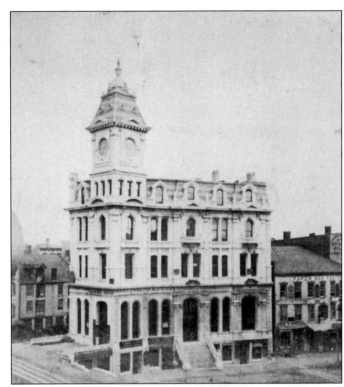

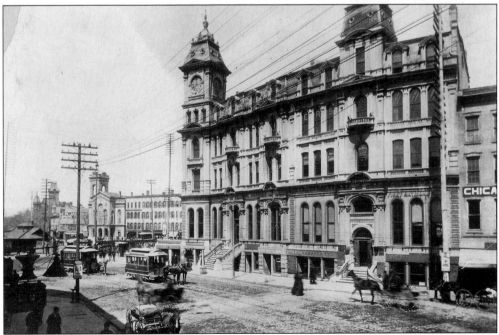

Gridley Building and East Water Street, c. 1880. The earlier brick structure at the far right is typical of the commercial style architecture that dominated central Syracuse from the late 1820s until the 1860s. Buildings like the Gridley introduced a more flamboyant "Victorian" look that would command the streetscape during the latter years of the nineteenth century.

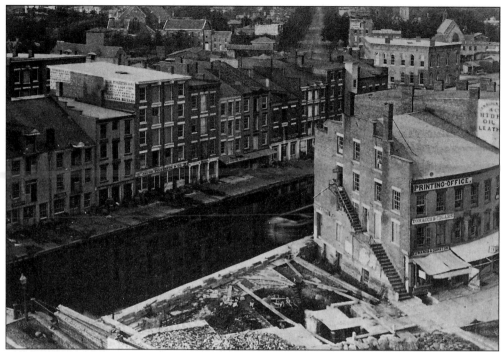

Loft Buildings along Erie Canal, 1867. These buildings had two business sides: one at the rear, for canal boat loading and unloading; and one facing the street for walk-in or delivery wagon activity. Note the excavation under way in the foreground for construction of what became the Gridley Building.

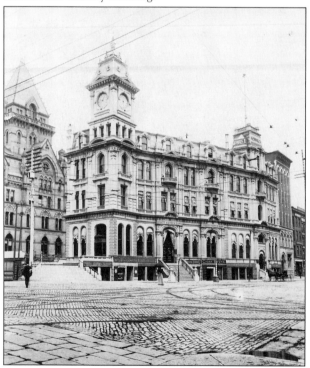

Gridley Building, c. 1895. Construction of Syracuse's finest Second Empire style commercial building began in 1867 to house the Onondaga County Savings Bank. Note the extensive use of stone paving blocks on Salina and Water Streets with larger blocks forming the crosswalks.

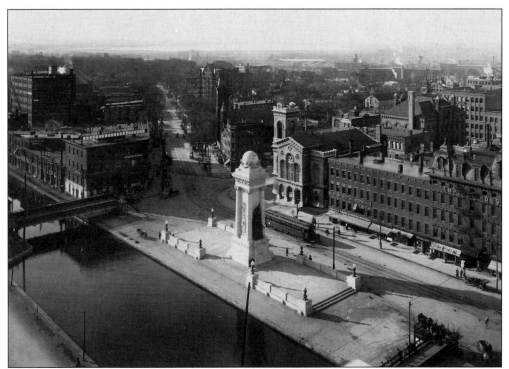

Clinton Square Looking Northwest along Genesee Street, c. 1915. By this decade, canal activity was becoming sparse. Drivers of horse-drawn vehicles and electric interurban railway motormen were learning to share the streets with automobiles. Note the salt fields in the distance and the Soldiers and Sailors Monument of 1910 in the foreground.

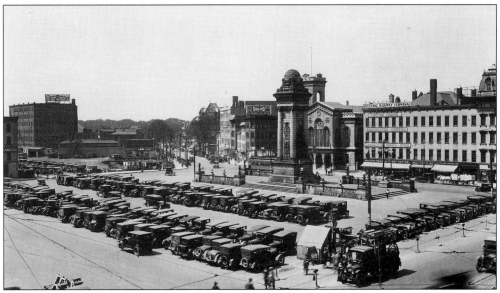

Clinton Square Looking Northwest, c. 1926. Just ten years after the previous view, the automobile demonstrates its growing dominance of the cityscape. The former space occupied by the Erie Canal in the square has recently been filled-in and become a busy parking lot. Note the site on the left, cleared to erect the new federal post office.

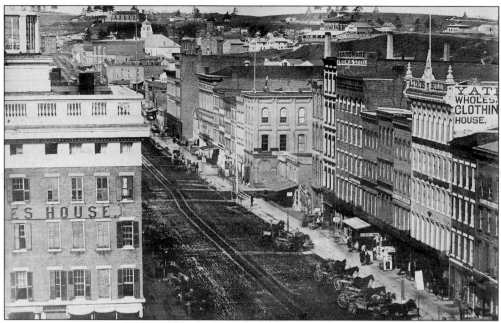

North Salina Street from Clinton Square, c. 1865. The impressive cupola and balustrade identifies the Greek Revival style Empire House, which formed the northern edge of Clinton Square. North Salina Street is the commercial thoroughfare that linked the central city with its salt manufacturing district near Onondaga Lake. Much of the hilly terrain on the north side was still undeveloped at this time.

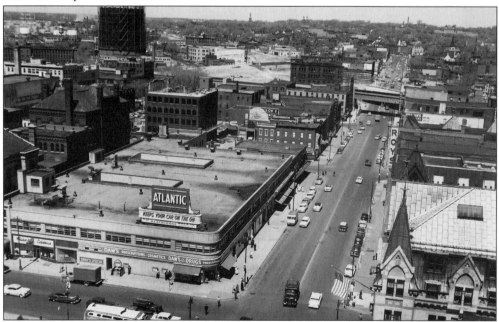

North Salina Street from Clinton Square, 1958. The landmark Empire House that dominated the north side of Clinton Square for most of the nineteenth century was lost in a 1941 fire and replaced for a time with this streamlined, international style business block. Church steeples are prominent on the north-side horizon as is North High School in the upper right.

South Salina Street Looking North from Fayette Street, c. 1878. The length of time required to expose images in early photography often meant that only objects standing still would appear, sometimes giving an empty appearance to street scenes like this.

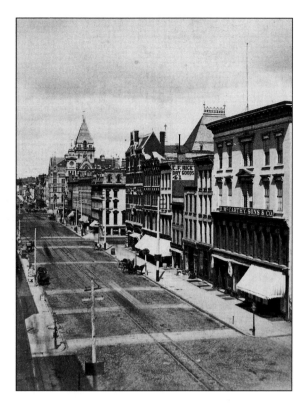

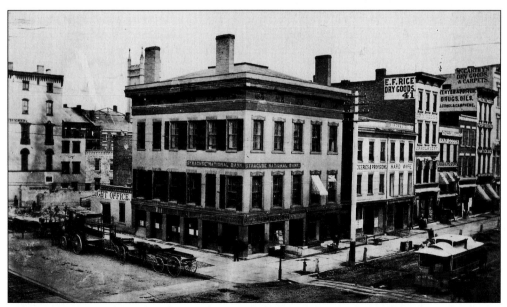

Southeast Corner of South Salina and East Washington Streets, 1876. Demolition has begun on the freight office structure to the rear of this Greek Revival style commercial building. Eventually the entire corner would be cleared to erect the White Memorial Building. The steeple of the second St. Paul's Episcopal Church (1842) is visible to the rear.

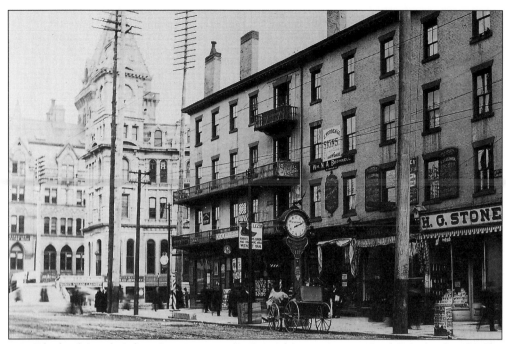

100 Block of South Salina Street, c. 1895. One of Syracuse's pre-Civil War landmarks, the Onondaga House, is seen on the corner in its last days, just prior to its demolition. The site became the location for the new Onondaga County Savings Bank.

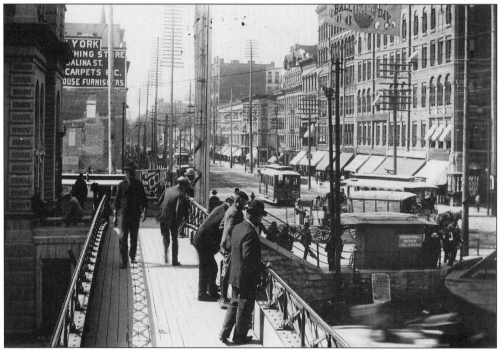

Salina Street Pedestrian Bridge, 1896. An excellent place to watch the passing canal and street traffic was this stationary footbridge over the Erie Canal. Electric railway and horse-drawn vehicles crossed the canal at this time via a separate swing bridge located to the right.

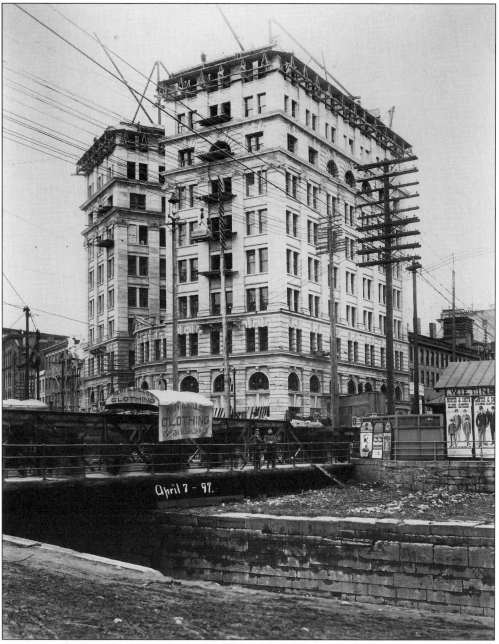

April 7 - 97.

Onondaga Savings Bank (OnBank) Building, 1897. Exterior construction appears almost completed on one of Syracuse's first steel-framed, high-rise buildings. The structure to the right, at the canal's edge, is noted as a "comfort station" on the original photograph.

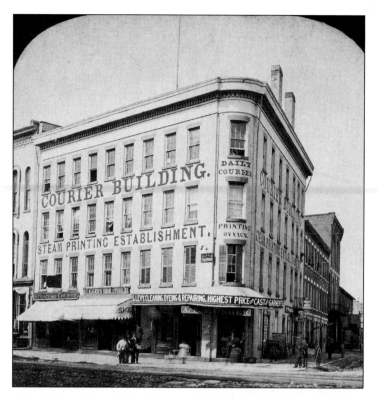

Courier Building, c. 1875. Located at the northwest corner of East Genesee and Montgomery Streets, opposite City Hall, this structure was named after a local newspaper once published there. It stands today as one of the oldest buildings in downtown, dating from about 1844.

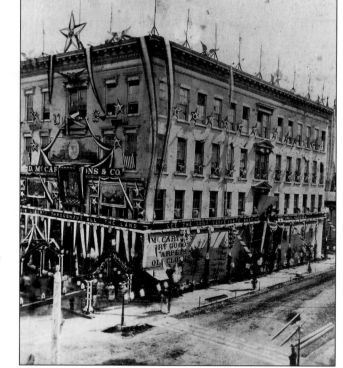

D. McCarthy & Sons, c. 1875. The exuberance of a patriotic nineteenth-century celebration is exemplified in the bold decorations displayed on one of Syracuse's leading department stores, located for years at the northeast corner of South Salina and Fayette Streets.

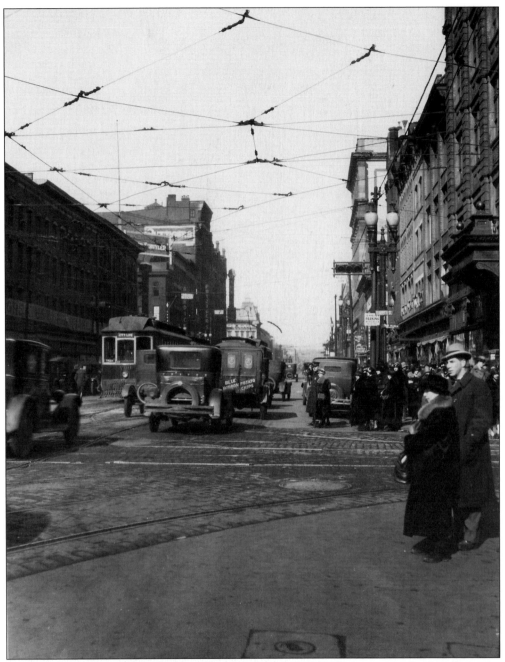

South Salina Street at Fayette Street Looking North, 1925. Shoppers crowd sidewalks in the days when one could literally count hundreds of retail establishments in downtown Syracuse. The pattern of overhead wires was used to transmit power to the electrically run streetcars, like the one visible on the left.

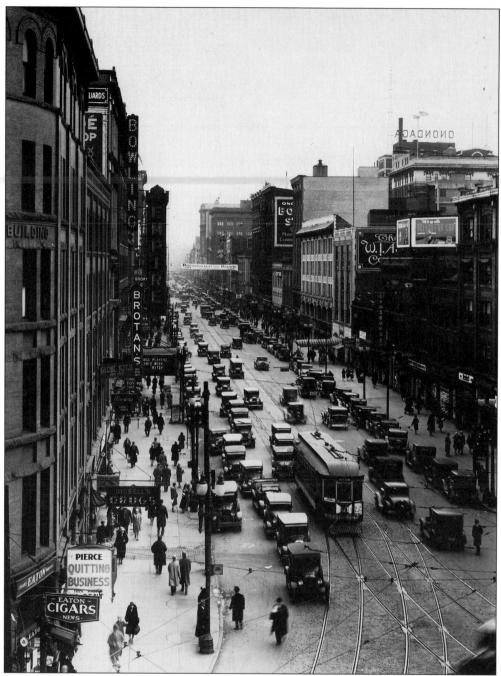

South Salina Street, 1930. It was a challenge for automobile drivers to negotiate Syracuse's main streets in the days when public transportation was still dominated by electric streetcars. This view, looking west, was taken north from West Onondaga Street.

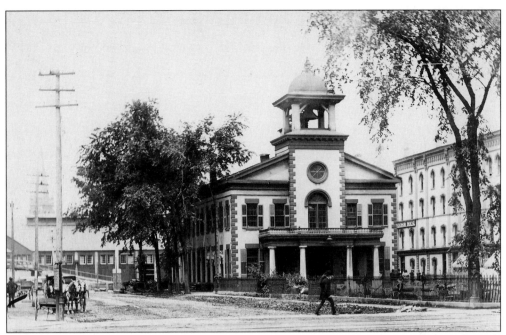

Syracuse's First City Hall, c. 1889. This building was erected in 1845 as "Market Hall" with retail stalls on the first floor and village offices above. It was renamed when Syracuse became a city in 1848. The bell tower, added later, served as the city's fire alarm.

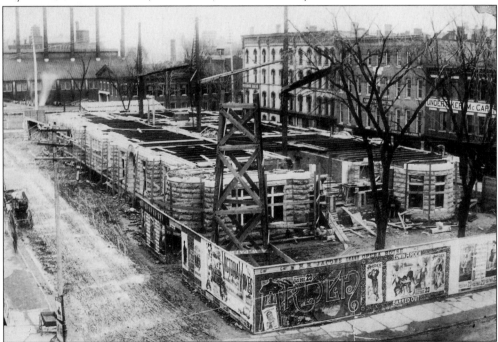

Construction of the Present City Hall, 1889. By 1889, the forty-year-old city needed larger government quarters, so a new city hall was built on the site of the old facility. Note the use of heavy masonry in the exterior walls to bear the building's structural load. The Erie Canal weighlock building is visible in the background.

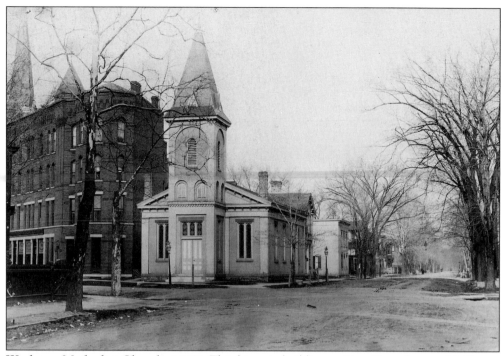

Wesleyan Methodist Church, 1890. This historic building at East Onondaga and Jefferson Streets dates from 1845, when Syracuse was still a village. Here, its neighborhood remains primarily residential. The original congregation members were active abolitionists. The site, still standing today, is believed to have been a likely station on the Underground Railroad.

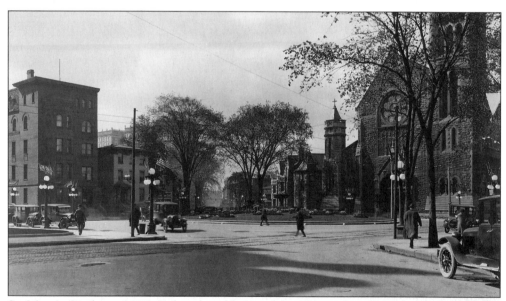

St. Mary's Circle, c. 1925. Before the addition of the Christopher Columbus statue in 1934, this intersection's identity reflected the original name of the Roman Catholic cathedral located on the right. Note the impressive canopy of elm trees lining East Onondaga Street.

Cathedral of the Immaculate Conception, Early Twentieth Century. Construction started in 1886 on this Victorian Gothic Revival edifice, originally called St. Mary's, but re-consecrated as the diocesan seat in 1910. This view documents the interior before remodelings of the altar area in 1958 and 1985.

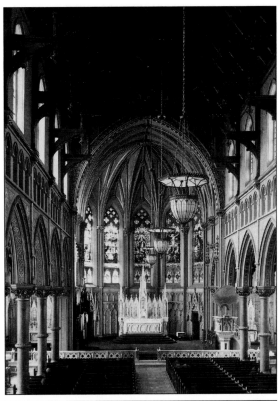

Southwest Corner of Montgomery and East Washington Streets, 1891. The destructive force of urban fires, before the days of modern fire-fighting equipment and dependable municipal water systems, is clearly demonstrated here in the ruins of the Montgomery Flats apartments. The emptied site was soon filled by the construction of the Yates Hotel.

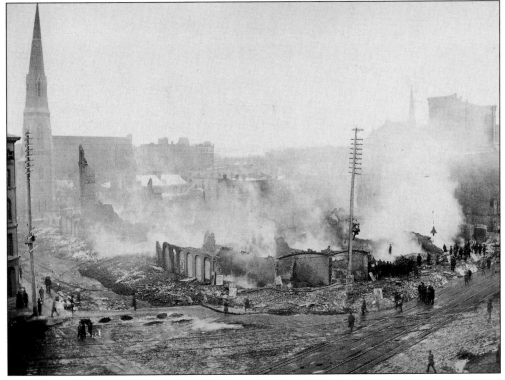

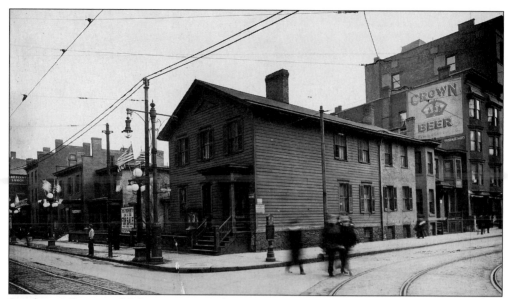

Southeast Corner of Montgomery and East Fayette Street, 1916. This block remained predominately residential until about 1900. Soon after this photograph was taken, these vestiges were demolished in order to provide space for a new commercial building. Today, a parking garage occupies the corner, but the "Crown Beer" sign is still partly visible.

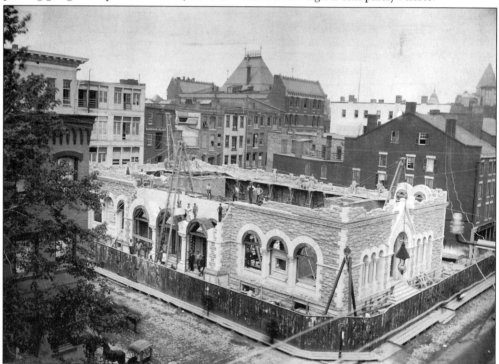

Construction of the Post Office Building, c. 1885. It took over four years to complete construction of this monumental structure at Fayette and Warren Streets. Note the temporary wooden forms used to set the heavy stone arches in place. The distinctive roof line of the White Memorial Building is visible in the distance.

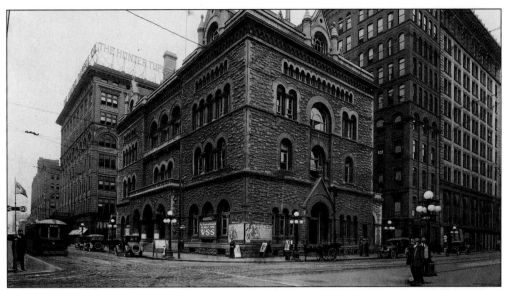

Northwest Corner of Warren and East Fayette Street, c. 1918. This Richardsonian Romanesque-styled stone edifice housed federal offices and the main post office beginning in 1889. The building was free-standing, which accounts for the detailed facade of the adjacent C.W. Snow Building of 1888 that faced it to the right. Note the traffic control semaphore at the extreme left.

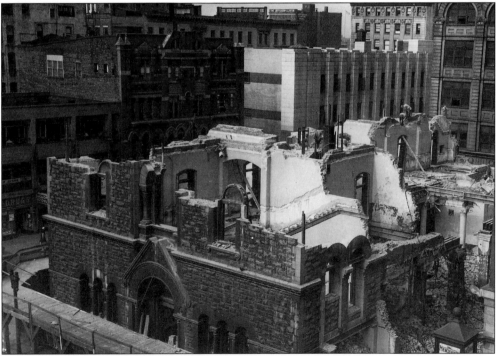

Demolition of the "Old" Post Office, 1949. This view exposes the interior of this massive Onondaga limestone building. It was razed to make space for an expansion of Merchants Bank, but that did not occur for over a decade. The demolition took four months, and workers labeled it one of the best-built structures that they had ever tackled.

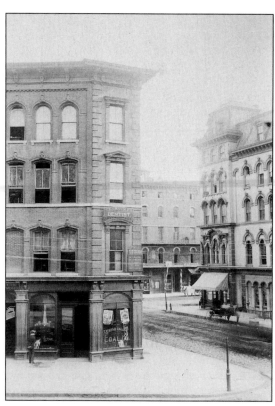

Warren and East Genesee Streets, 1886. At this date, the Granger Block had not yet been renovated, via the addition of three additional floors, and renamed the SA&K Building (now City Hall Commons). The Larned Building (right) also still retained its original mansard roof, which was subsequently altered into its present configuration.

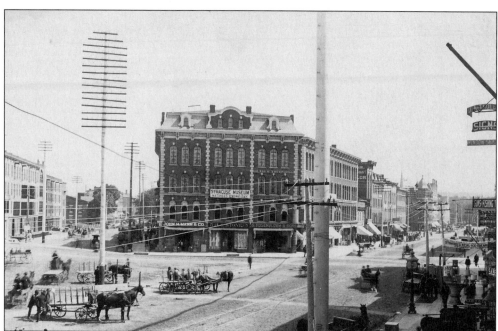

Hanover Square, c. 1878. The 1863 Bastable Building anchors the east side of the square. It burned in 1891, was rebuilt, then burned again in the 1920s, and was subsequently replaced with the State Tower Building. Note the huge size of the telephone poles.

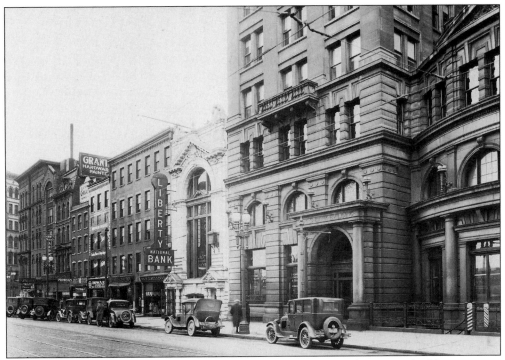

Hanover Square, South Side, c. 1920. All of these nineteenth-century buildings remain today, part of the reason that Hanover Square became Syracuse's first historic district in 1976. Note the original curved configuration of the first three floors of the Onondaga County Savings Bank Building.

Atlantic Building, North Salina Street Facade, c. 1952. This simple, international style building was erected in 1950 to replace the century-old Empire House, which had burned in 1942. It remained on the north side of Clinton Square only until 1968, when it was demolished for construction of the Syracuse Newspapers building. (See page 14.)

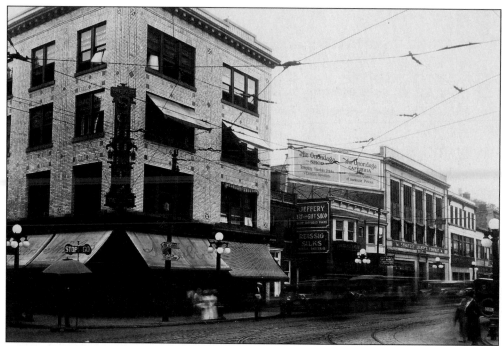

Southeast Corner, Warren and East Jefferson Streets, 1924. In this view, Warren Street had clearly entered the twentieth century, but traffic was still controlled by just a lettered semaphore. A residential vestige from the early nineteenth century is also visible, sandwiched between more recent commercial structures.

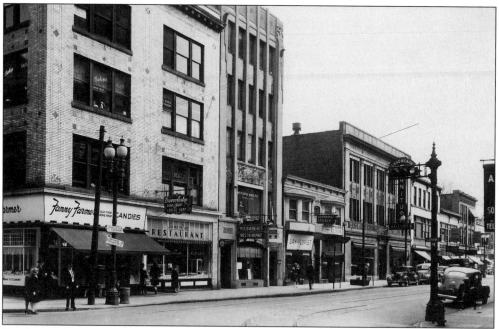

Southeast Corner, Warren and East Jefferson Streets, 1941. Electric traffic signals have replaced the semaphore, streetlights are higher for more illumination, and a marvelous Art Deco gem, the Weiler Building of 1928, has replaced the Federal style house.

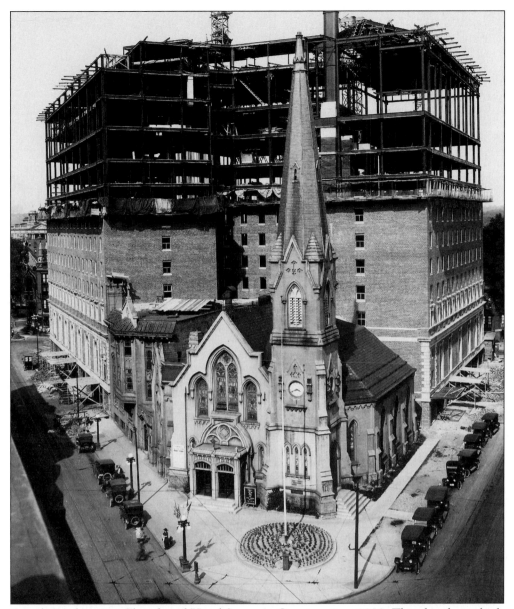

Fourth Presbyterian Church and Hotel Syracuse Construction, 1923. This church was built in 1877 to the Victorian Gothic designs of local architect Horatio Nelson White. It could seat eight hundred people, and the tower was reported to be 155 feet tall. In 1941, the congregation left to merge with First Presbyterian, and the structure was demolished in 1943 for a parking lot. Today the church site is occupied by a ballroom wing, which was added to the hotel in 1981.

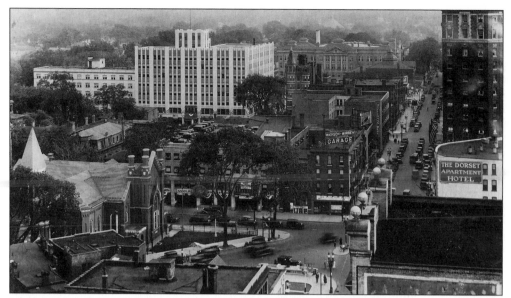

Intersection of South Warren and East Onondaga Streets, 1931. The Madison-Warren Garage, a good example of downtown's early auto parking facilities, occupied part of the site that became the MONY complex in the 1960s. Plymouth Congregational Church is visible at left.

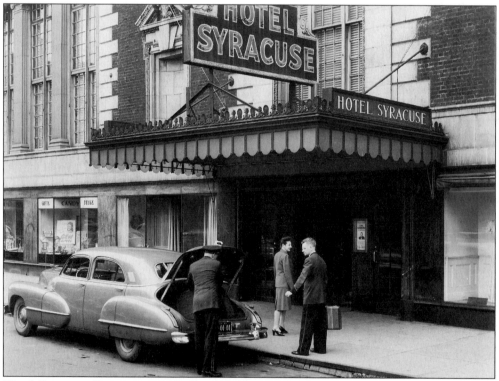

Hotel Syracuse Entrance, 1945. Since its opening in 1924, this hotel has been a hub of downtown activity. Here the doorman and a bellboy unload luggage from what appears to be a 1942 Cadillac.

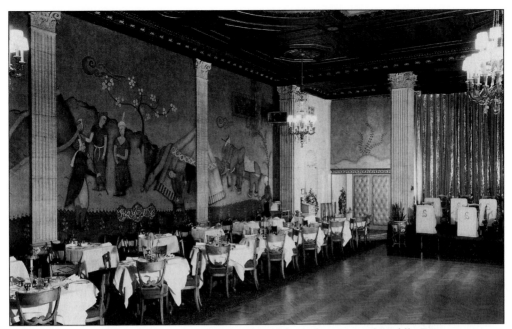

Persian Terrace, Hotel Syracuse, 1940. A fanciful combination of Middle Eastern imagery with neoclassical architecture made this popular room a unique venue for showcasing live music of the Big Band era.

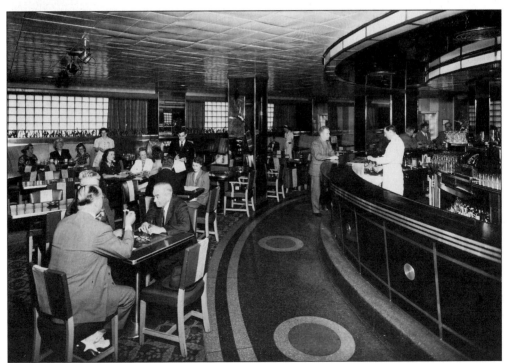

Rainbow Lounge, Hotel Syracuse, 1948. This epitome of late Art Deco design was added to the hotel in 1937. It immediately became one of the city's premier barrooms. Unfortunately, its style has been totally lost in subsequent hotel remodelings.

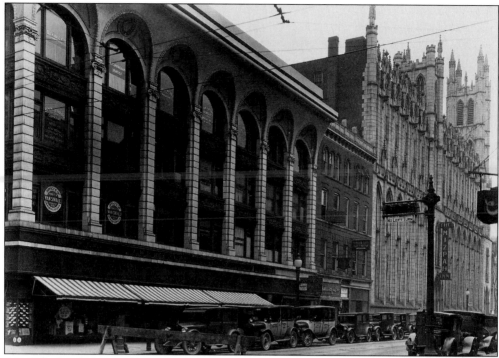

200 Block of East Jefferson Street, c. 1928. The 1910 Seitz Building once boasted a magnificent cornice, but fifth-floor tenants were unable to see the street. This bold detail was removed in 1948. The First Baptist Church, which included hotel rooms on its upper floors, is visible on the right.

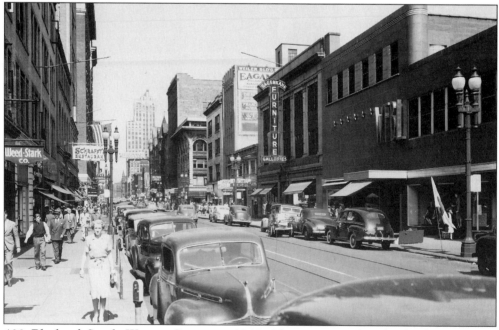

400 Block of South Warren Street, c. 1948. This image evokes the bustling scene in downtown's heyday when Schrafft's Restaurant was the leading place for a fashionable lunch.

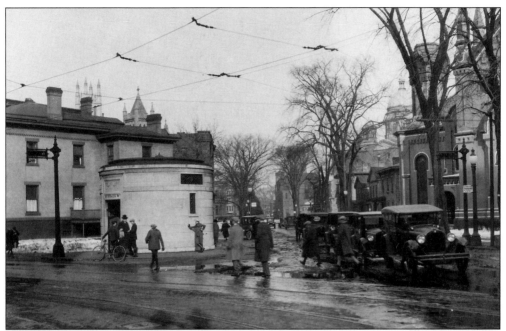

Northeast Corner of South Warren and East Onondaga Streets, 1925. Syracuse opened these underground public rest rooms in 1921. They were soon nicknamed "Napoleon's Tomb" because of the resemblance to a mausoleum. Later remodeling simplified the entrance. These facilities were eventually removed from service in 1962 with construction of the 499 South Warren Street Building.

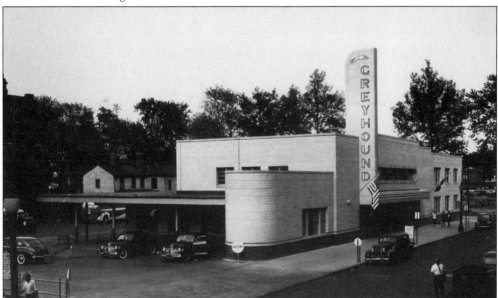

Greyhound Bus Terminal, c. 1948. This streamlined International Style depot opened in 1941 at the northwest corner of Montgomery and Harrison Streets. Its design reflected some of the "modern" architecture of the period that was evident at the 1939–40 New York World's Fair. Its sleek lines also echoed the notion of speedy transportation by motorized coach. The terminal lasted a scant twenty-three years and was torn down to make way for MONY Plaza.

Northwest Corner, Crouse Avenue and University Place, 1894. The neighborhood immediately north of Syracuse University developed in the late nineteenth century as predominately residential. Note the importance of porches to late-Victorian architecture.

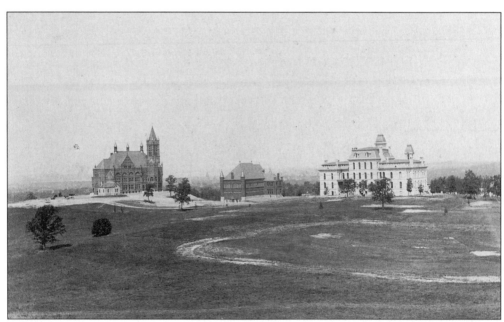

Syracuse University Campus, c. 1890. The campus was still sparse and remote from the city at this time, but boasted some fine architecture. Fortunately, all four of these earliest buildings have survived. From left to right the buildings are as follows: Crouse College (1889), Holden Observatory (1887), Von Ranke Library (1889), and Hall of Languages (1873).

View Southeast from Crouse College, c. 1900. This unusual stereographic view shows an early, seven-hole golf course laid out in 1899–1900, just beyond the southern edge of the campus.

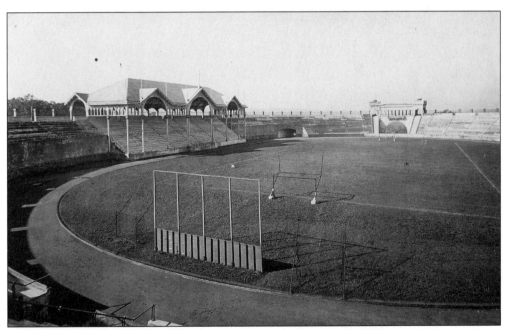

Archbold Stadium, c. 1920. When completed in 1907, Syracuse University's new concrete coliseum was considered by some to be its most impressive campus edifice. The site of many famous athletic achievements, the stadium was replaced by the Carrier Dome in 1979.

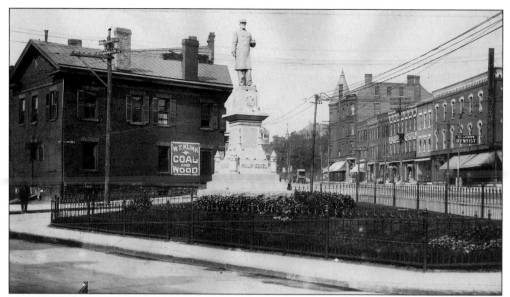

North Salina and Butternut Streets, 1911. This intersection was near the heart of Syracuse's nineteenth- and early-twentieth-century German community. It was the proud home of the 1900 statue of German-born Philip Eckel, a Syracuse fire chief killed in 1886 while en route to a fire. The statue now stands in Fayette Park.

Dr. Amos S. Edwards Home, c. 1885. Dr. Edwards (at right) practiced and lived here at 1506 North Salina Street, near Bear Street, until his death in 1931. Harry S. Edwards (his son standing on the far left) graduated from Syracuse University, became a lawyer, and also lived here until his death in 1941.

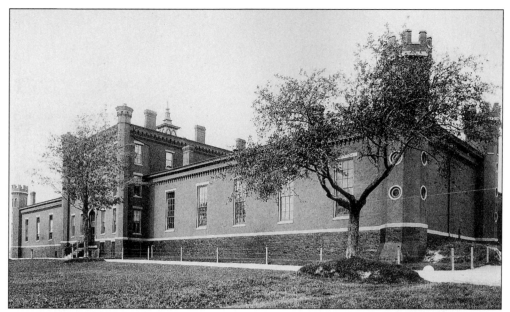

Penitentiary at Pond and Lilac Streets, 1894. Originally constructed in 1850, this county prison partially burned in 1864. It was rebuilt in 1866 to the designs of Horatio White. The center section held administration spaces and a large chapel. Cells were in each wing, one side for females and one for males. It was replaced in 1901 by the "old" Jamesville Penitentiary.

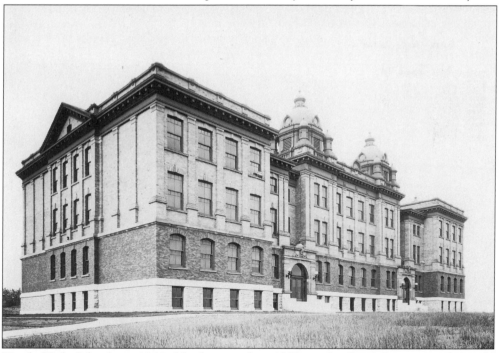

North High School, c. 1910. North opened in 1908 on the Pond Street site of the old penitentiary. Many thousands of "Northside" students graduated from here, until it closed in 1964 and was replaced by Henninger High School. Most of the structure was demolished in 1965.

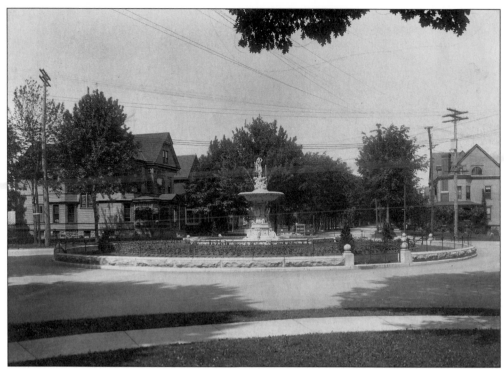

Leavenworth Circle, c. 1890. In the 1890s, West Onondaga Street was one of the city's most fashionable concourses. This circle, where Onondaga meets Delaware Street, was created in 1889 through the donation of land to the City by surrounding residents. Most of the fountain was pulled out in 1934.

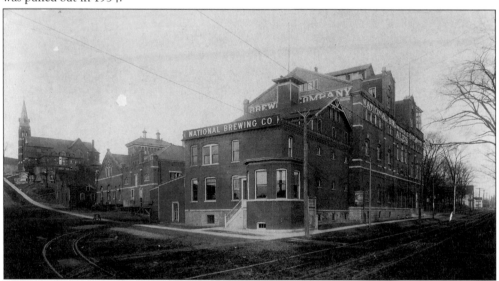

National Brewing Company, c. 1910. This facility at the northeast corner of Vine Street and Burnet Avenue was built in 1887 as the Crystal Spring Brewing Company. When photographed, it was actually being run by the local Haberle brewing concern, which had acquired rights to the "National" name from the buyout of even another local brewery. St. Vincent De Paul Church is visible at left.

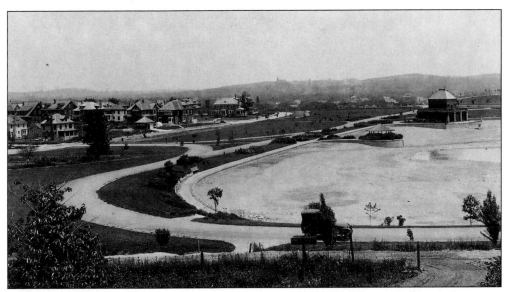

Upper Onondaga Park and Crossett Avenue, c. 1915. The former Wilkinson Reservoir became the central feature of this west side park, whose landscape dates primarily from 1911 to 1914. Note the water system's old gatehouse which remained for several years after the reservoir was renamed Hiawatha Lake.

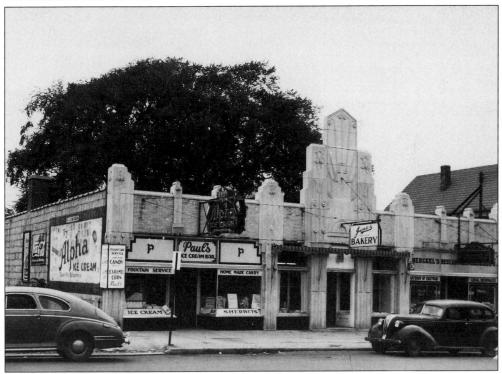

Numbers 2339–2343 James Street, c. 1950. Built about 1930, this splendid Art Deco building was at the western edge of Eastwood's commercial district and housed some very traditional community businesses. Neighborhood ice cream parlors remain a fond memory for many born before 1960.

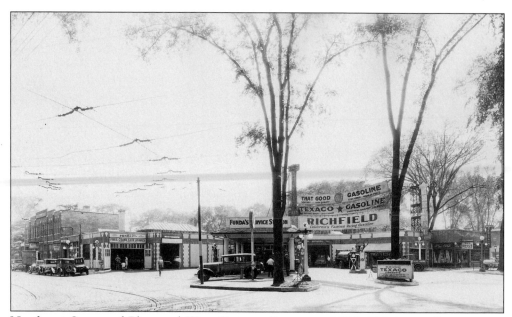

Northeast Corner of Plum and West Genesee Streets, c. 1930. This image illustrates just a sample of the new commercial activity developed by the 1920s to cater to the growing legion of motorists.

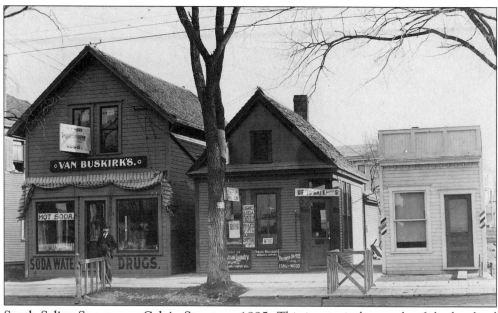

South Salina Street near Colvin Street, c. 1895. This is a typical example of the localized services found throughout Syracuse's turn-of-the-century neighborhoods.

Number 120 Shonnard Street, c. 1890. This tidy, late-nineteenth-century home is similar in style to many that lined side streets in the outer neighborhoods immediately surrounding downtown. These districts developed during the city's growth in the decades following the Civil War.

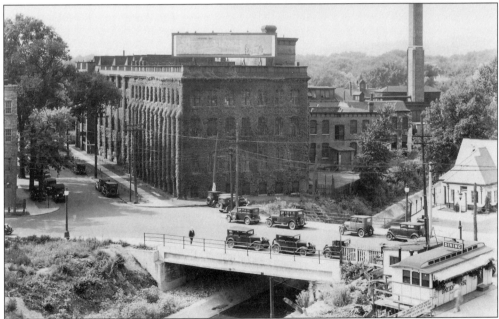

Stearns Factory, West Adams and Oneida Streets, c. 1925. E.C. Stearns & Co. started in 1877 manufacturing hardware, but became known for the bicycle line it added in 1892. Stearns expanded, employed 1,500 workers in 1896, and ran branch operations in Toronto and San Francisco. In 1935 it moved to Eastwood, but by 1956 the business was in bankruptcy. This building burned in 1945.

Greyhound Building, 1895. Built in 1884 at the northwest corner of James and Warren Streets, this combination residential and commercial block took its name from an early, two-story frame tavern that once stood there. This namesake was demolished in 1961 for a parking garage that was never built. Note the greyhound motif just under the roof line.

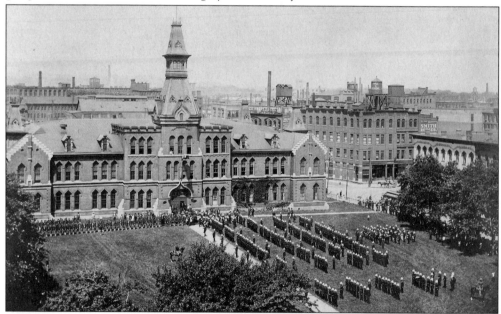

State Armory, c. 1900. This view shows the 1874 version built on the site at West Jefferson and South Franklin Streets, before extensive renovations in 1907. The early-twentieth-century warehouse and manufacturing character of the area west of downtown is clearly seen here.

Two

Trades and Talents:
The Tapestry of Working Lives

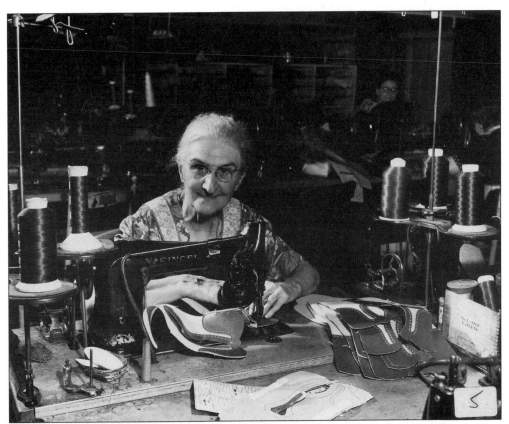

Nettleton Factory Worker, c. 1950. Syracuse's famous shoe manufacturer started production in 1879. By the 1920s, its North State Street factory had the daily capacity to produce 2,500 handmade shoes. The company employed 450 workers in 1954, but changing economic forces brought closure by 1984.

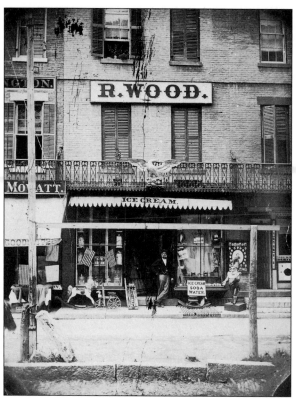

Reuben Wood's Store, c. 1869. Over 125 years ago, one could buy a refreshing treat from this establishment. In the years just after the Civil War, this was a typical-looking South Salina Street storefront. It stood a short distance north of today's Landmark Theater.

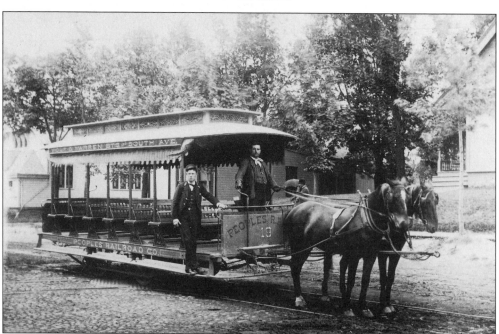

Peoples Railroad Company Employees, c. 1890. Syracuse obtained its first horse-drawn street railway in 1860. This car is pictured on the system's turntable in the 600 block of South Avenue.

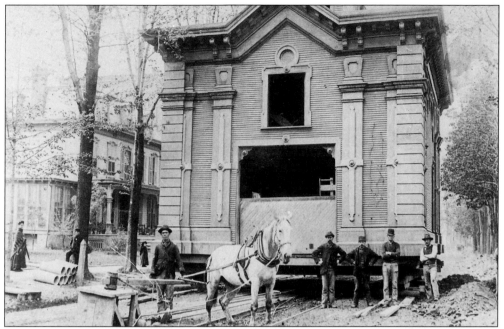

Moving Milton Price's Stable, c. 1893. When Price's mansion at South Salina and East Jefferson Streets became the site for the Dey Brothers department store, workmen recycled this outbuilding to another site. This was a more common occurrence in the nineteenth and early twentieth centuries than it is today.

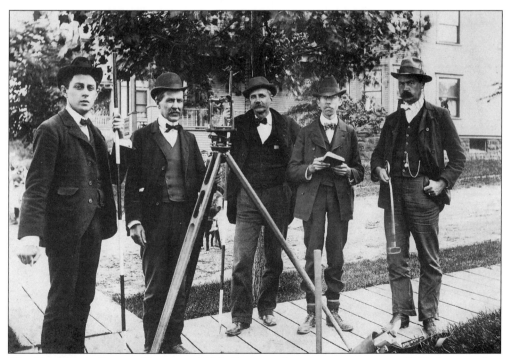

City Engineer's Survey Team, c. 1905. Since its formation as a city in 1848, Syracuse has employed an array of civil servants to guide the Salt City's physical growth.

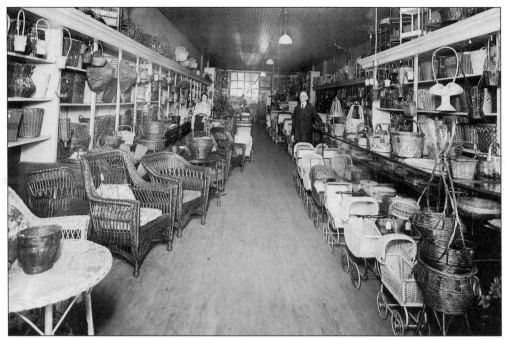

L.L. Thurwachter & Sons Store, *c.* 1920. Located at 215 West Fayette Street, this family-owned business was a long-standing retail outlet for wooden goods and Liverpool, New York–made willow ware.

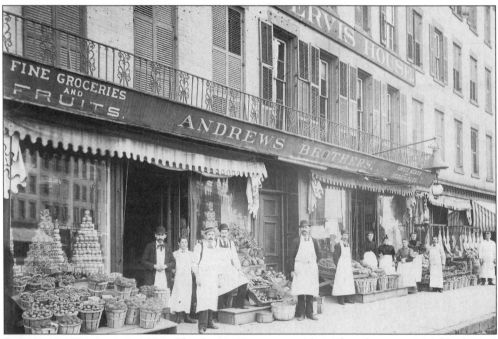

Downtown Grocers, *c.* 1893. The Jervis House, a residential and commercial block, was located at the southwest corner of East Fayette and South State Streets. When large sections of downtown were still residential neighborhoods, grocery establishments like that of J.M. and Harlon Andrews, flourished. Note the display of fresh meat on the far right.

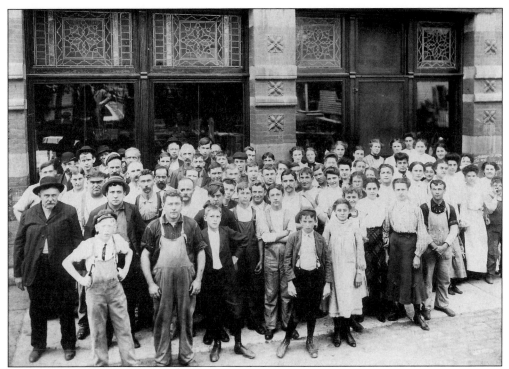

Francis Will Candle Company Employees, c. 1910. Syracuse has a rich tradition of candle-making dating back to the 1850s. The work force in front of this North Alvord Street location included some very young "Northsiders." Note the photographer's reflection in the window on the left.

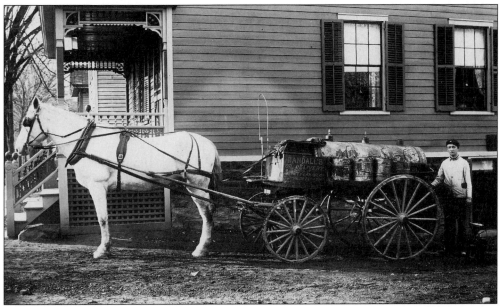

Horse-drawn Deliveries, c. 1894. Nineteenth-century Syracuse functioned literally on horse power. This small enterprise was typical. It likely is Lynn S. Randall, listed briefly in city directories at the time as an oil dealer, probably for oil lamps and other household use.

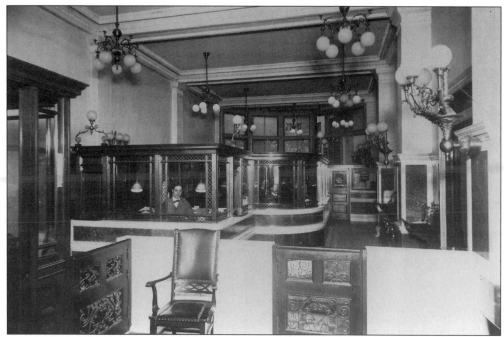

First National Bank Clerk, c. 1900. At this time, First National occupied the eastern (East Genesee Street) side of the present OnBank Building. The young teller seen in these rather formal surroundings, Arthur W. Loasby, was apparently a hard-working employee. He eventually became the board chairman of First Trust & Deposit.

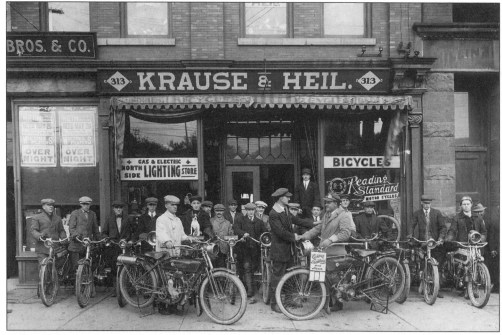

Selling Motorcycles on North Salina Street, c. 1910. City directories listed Krause & Heil as a bicycle repair shop, but it was clearly a diversified business. There are no helmets in sight, and the Jack Russell terrier was certainly optional "equipment."

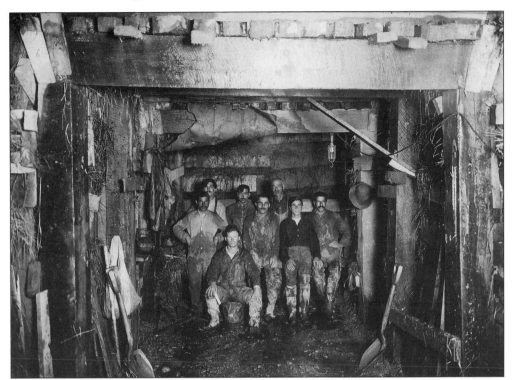

Sewer Workers, 1911. In an era when a significant amount of physical labor was still performed by hand, these men take a break from constructing the major intercepting sewer line under West Genesee Street.

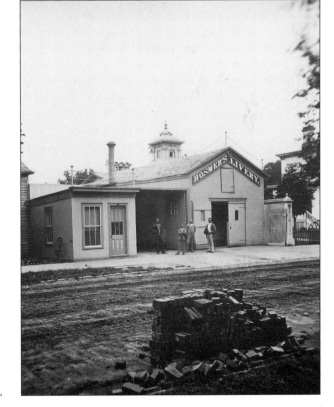

Livery Stable on East Jefferson Street, 1876. Hosmer's Livery was situated where Deys Centennial Plaza now stands. It was one of the dozens of indispensable stables located throughout nineteenth-century Syracuse when horses were in daily use on virtually every street.

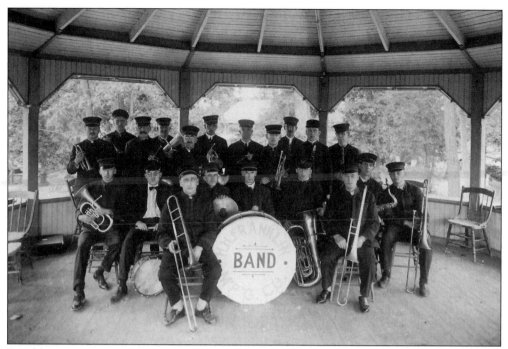

Franklin Manufacturing Company Band, 1918. This Geddes Street auto manufacturer was Syracuse's largest employer in the 1920s. Its employee band entertained at community gatherings and workers' social functions.

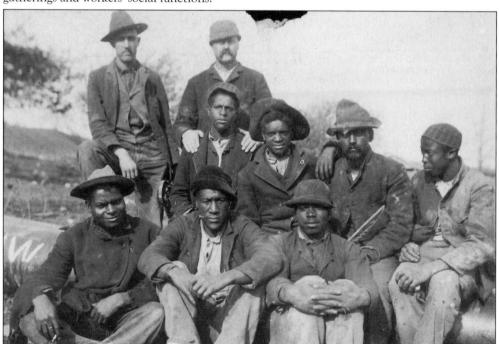

Woodland Reservoir Construction Workers, c. 1893. One of the contractors building the city's new Skaneateles Lake-supplied water system employed African-American workers, reportedly recruited from Southern states.

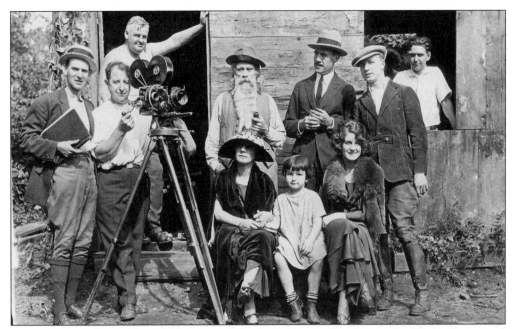

Cast and Crew of *A Clouded Name*, 1923. Local photographer Eugene Logan (with camera) produced this silent film in and around Syracuse. Scenes were filmed at the State Fair, the Calthrop mansion, and at Liverpool's solar salt fields. Three years later, the salt works closed, making this film's footage the only known moving images of the city's famous salt industry.

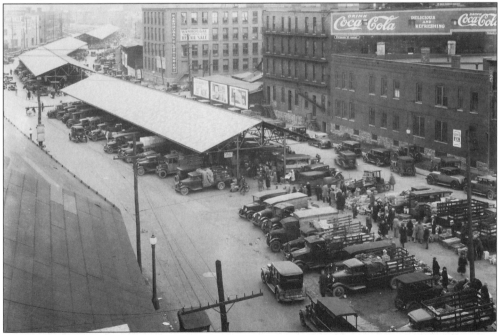

Farmers' Market, c. 1928. For decades, area farmers have brought their produce to the city in open market style. They used Clinton Square in the 1800s and then later, as pictured here, the area along the filled-in path of the former Oswego Canal, near Pearl Street. Beginning in 1938, the site shifted to the Park Street Regional Market.

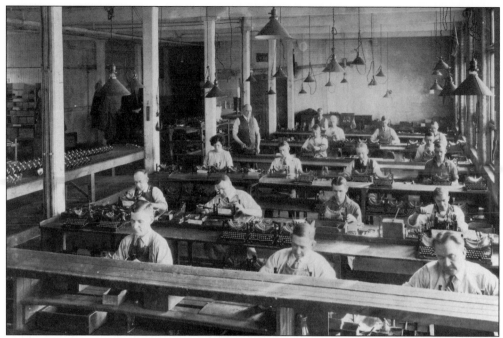

Typewriter Factory Workers, c. 1920. Syracuse was a major center for typewriter manufacturing in the early twentieth century, employing thousands. Here, workers assemble the typebar component for an office model at the L.C. Smith plant, located at Water and Almond Streets.

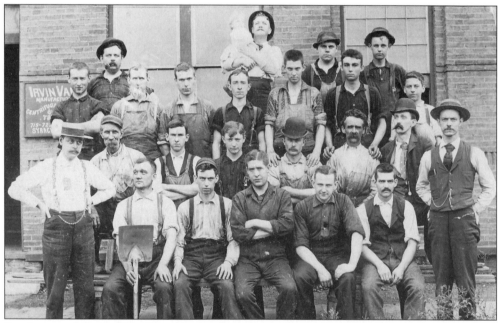

Employees of Irvin Van Wies Pump Factory, c. 1903. This manufacturing concern was located at 715–723 West Fayette Street, near Oswego Street. The no-nonsense clothing and the expressions on the faces of the workers reflect the hard-working nature of Syracuse's industrial heritage.

Franklin Factory, c. 1921. From 1902 to 1934, America's most successful air-cooled automobile was produced in Syracuse at the H.H. Franklin factory complex at South Geddes and Marcellus Streets. Thousands of Syracusans once worked there.

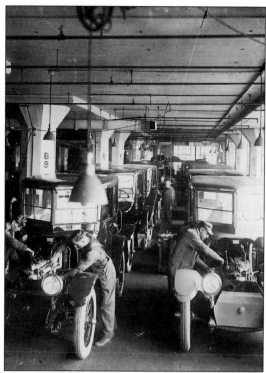

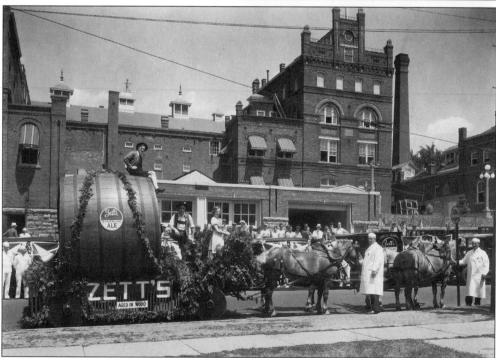

Zett's Brewery at Lodi and Court Streets, c. 1920. Syracuse's German population was concentrated on the city's north side in the nineteenth century. The district became home to several breweries from the 1850s through 1950s, employing hundreds of residents.

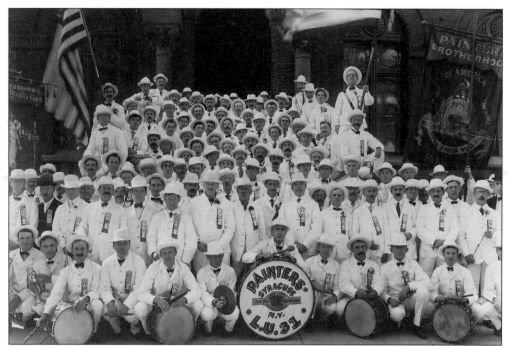

Union Gathering, c. 1895. Members of the Painter's Local Union 31, organized in 1887, gathered for this photo at the Willow Street entrance to the old County Clerk's Building.

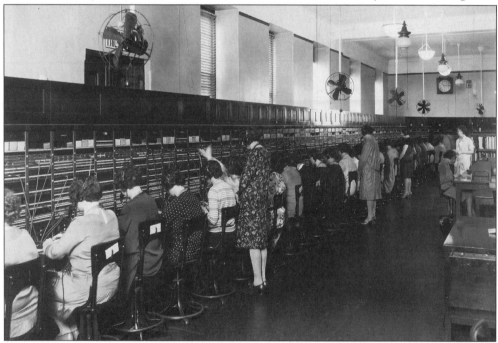

New York Telephone Switchboard Operators, c. 1925. A traditional opportunity for a woman to enter the work force was as a telephone operator, in the days when connections were still made by hand. This scene is inside the building at 321 Montgomery Street, now the home of the OHA Museum.

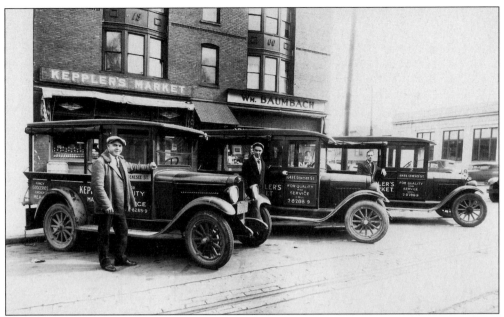

Keppler's Market Delivery Vehicles, 1924. Once, Syracusans could call a neighborhood market, like this one located on East Genesee near Cherry Streets, and have groceries delivered to their door.

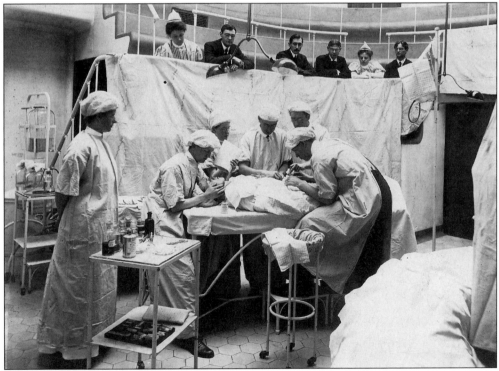

Hospital of the Good Shepherd, c. 1906. Syracuse has a long history of training personnel for the medical profession. At this hospital on Marshall Street, these were considered state-of-the-art surgical conditions in the early twentieth century.

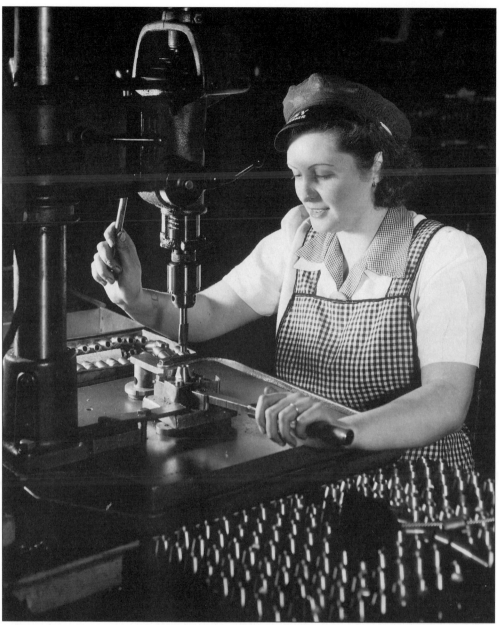

Defense Plant Worker, c. 1943. The Easy Washer Company made home laundry appliances in Syracuse, but during World War II it added military ordnance to its production line. Many local women went to work outside the home for the first time to help with the massive war effort.

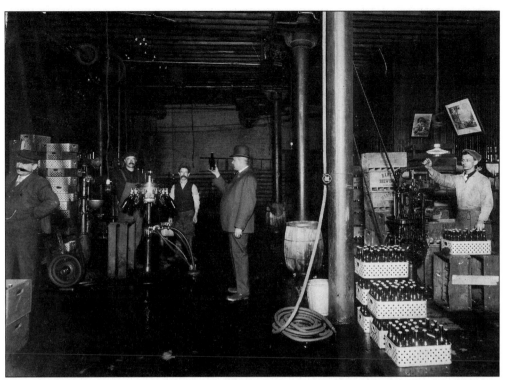

Brewery Employees, c. 1910. These workers are in the bottling room of Bartels Brewery, which was located alongside the Erie Canal at West Street.

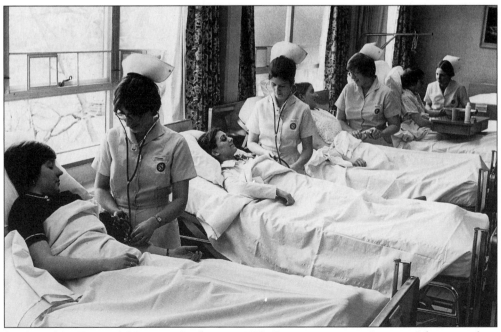

St. Joseph's Hospital Nursing Students, 1975. Promising nurses "practice" here on their fellow students.

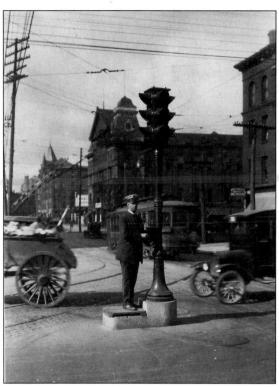

Policeman, 1924. One of Syracuse's traffic officers operates what is considered to be the first electric traffic signal in the country, at North State and James Streets. The Alhambra meeting hall stands in the background approximately where Interstate 81 crosses James Street today.

Firehouse Number 10, c. 1920. Here, Syracuse firefighters proudly pose with their motorized equipment. The Dutch Colonial style engine house, at the corner of Euclid and Westcott Streets, is presently a community center.

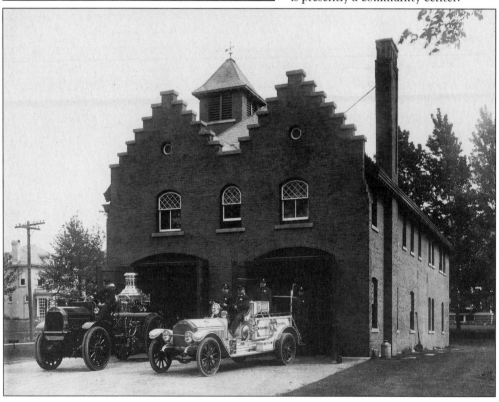

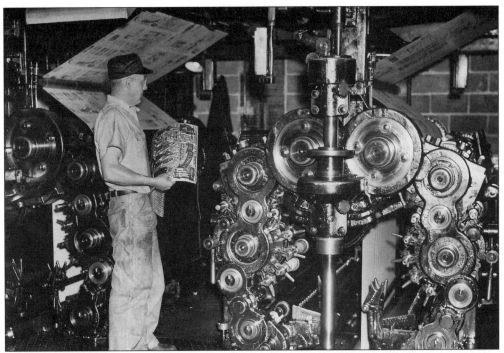

Newspaper Pressroom, c. 1945. In pre-computer days, the printing presses for the Syracuse dailies used heavy metal "plates" with raised printing surfaces.

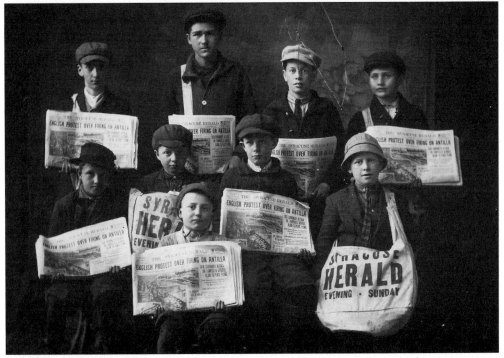

Newsboys, 1914. These boys likely sold the papers in their canvas bags on downtown street corners, rather than via door-to-door delivery.

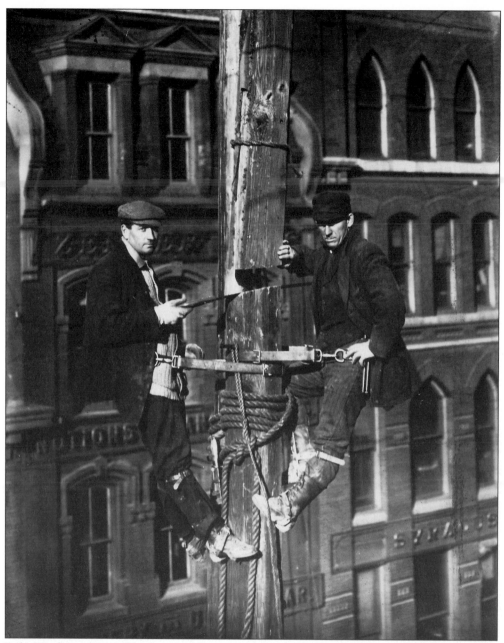

Pole Workers, 1923. These agile fellows appear to be in the process of removing a massive wooden telephone pole at West Fayette and Clinton Streets. These unsightly, towering structures proliferated in the late nineteenth century and cluttered downtown vistas until wires were relegated underground in later decades.

Three
Experiences Shared:
Pastimes and Passions

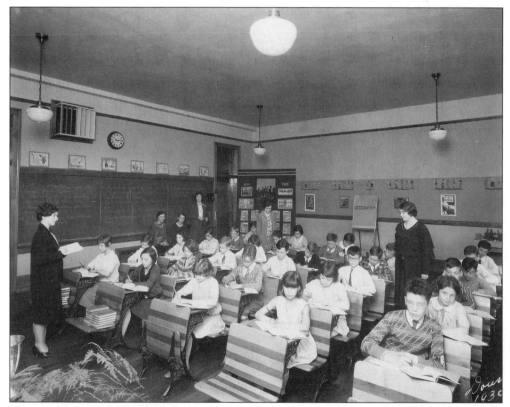

Elmwood School, 1930. Five new student teachers are seen training in Miss Tibby's classroom. Decor, clothing, and methods have evolved, but for students, the emotional highs and lows of attending school probably have not changed much at all.

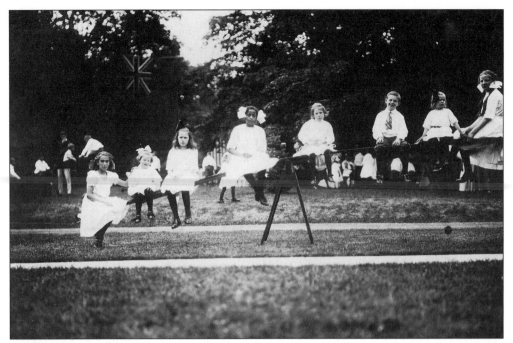

Orphans' Picnic, 1912. This homemade, but effective piece of playground equipment probably would not meet safety regulations today.

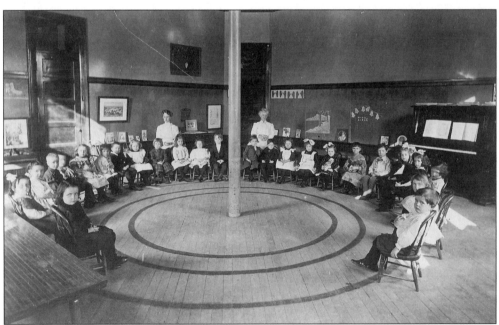

Afternoon Kindergarten Class at Tompkins School, 1910. This school served a west side neighborhood near Burnet Park. Classroom instruction was considerably more formal than in the 1990s.

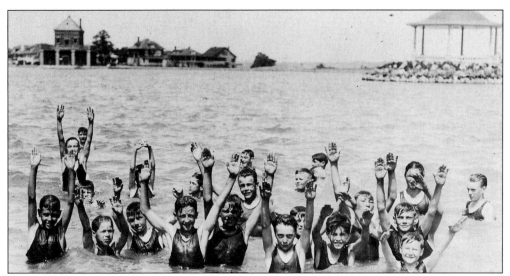

Hiawatha Lake, Upper Onondaga Park, c. 1920. Once landscaping and a bathhouse were added by 1914, this former reservoir became an extremely popular municipal swimming facility. Its use for swimming was later banned as dangerous and prone to spread disease.

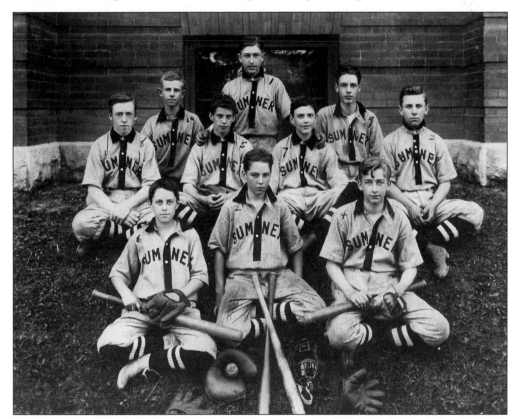

Sumner School Baseball Team, 1914. The equipment may differ, but the energy, enthusiasm, and emotions of kids playing the Great American Pastime makes a universal bridge from the past to the present. Sumner School was located on the city's east side.

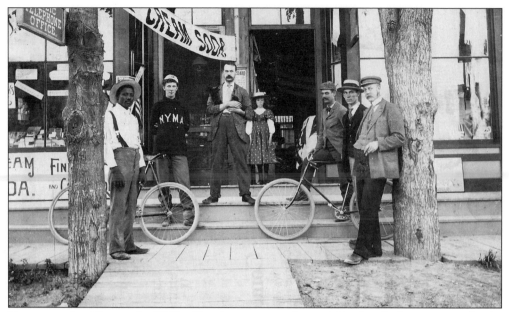

Drugstore in Elmwood, 1895. Hanging out at the neighborhood drugstore might be considered an early variation of today's "going to the mall." The Hanna & Coling Drug Store was located at the intersection of Glenwood and South Avenue in the Elmwood section, which became part of Syracuse in 1899.

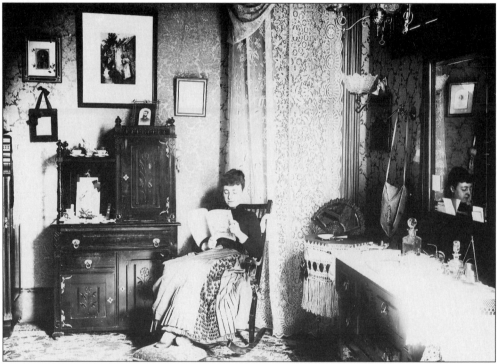

Olmsted Home, c. 1890. This home was located at 1036 South Salina Street, near Raynor Avenue. One wonders what the woman, possibly Clara Olmsted, is reading amidst the typical Edwardian decor of the period.

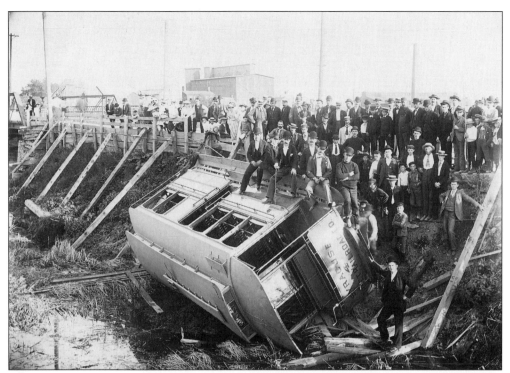

Street Railway Accident, c. 1905. It appears that the temporarily shored street embankment was not adequate for the weight of Car #4 on the Salina Street line of the Syracuse Street Railroad Company. It likely was a day the motorman wished he could forget.

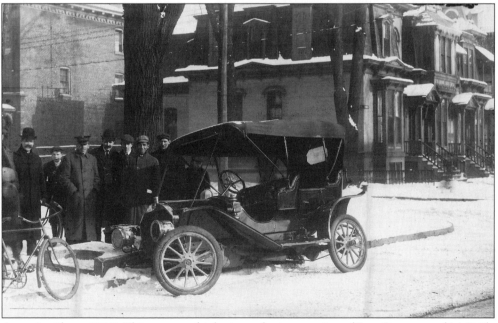

Auto Accident, 1910. This motor vehicle sits at the intersection of East Genesee and McBride Streets. The thieves who had stolen the auto crashed when they hit an old carriage stepping stone, once used to enter horse-drawn vehicles.

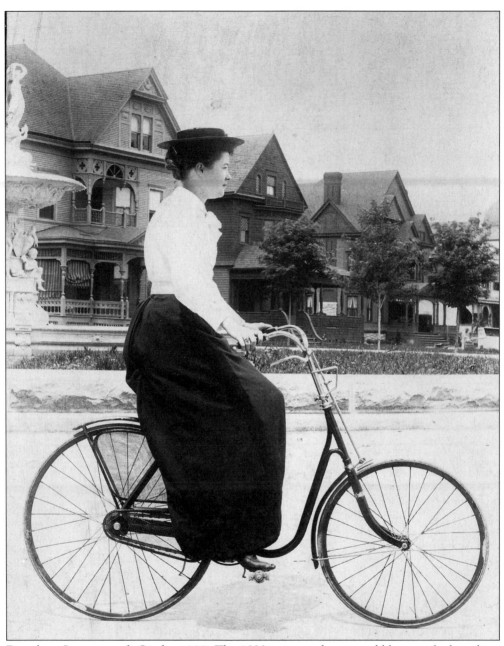

Bicycle at Leavenworth Circle, 1892. The 1890s witnessed an incredible craze for bicycling. Here, Clara Plumb demonstrates the fashionable style for peddling along West Onondaga Street on a July day.

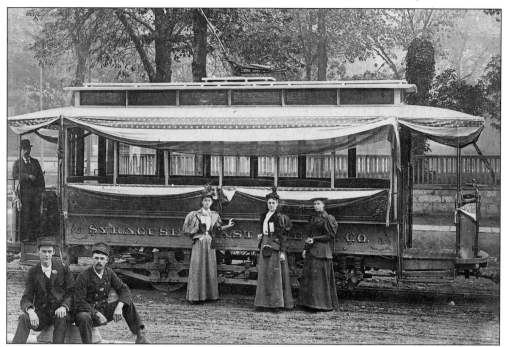

East Syracuse Trolley on Burnet Avenue at State Street, 1895. Motormen and riders pose with the latest in electrically-powered, urban transit vehicles. The arrival of the gasoline-powered auto, just a few years later, would eventually consign the trolley to oblivion by 1941.

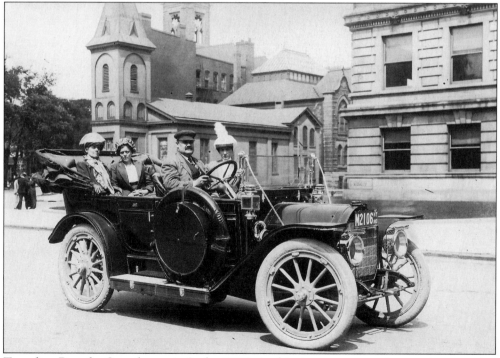

Traveling Past the Courthouse in Style, 1913. At this time, autos were just starting to evolve from a luxury item for the wealthy to an affordable necessity for the masses.

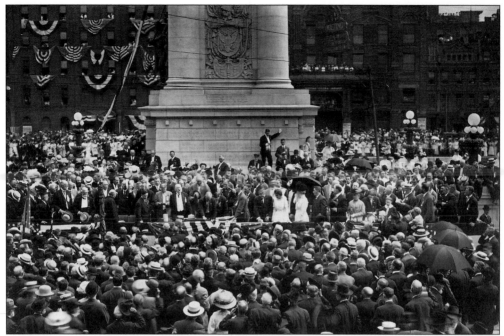

Dedication of the Soldiers and Sailors Monument in Clinton Square, 1910. This event brought the community together to honor the memory of Onondaga County's Civil War veterans. Today, Clinton Square remains one of the city's great historic civic spaces.

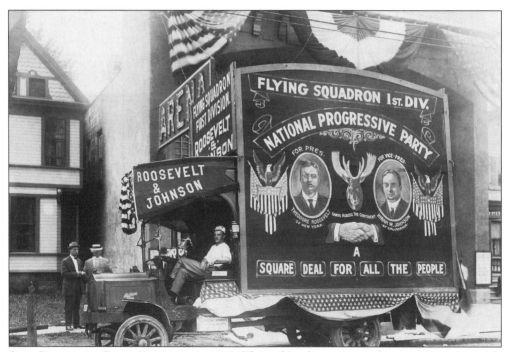

State Progressive Party Convention, 1912. This political association, known more commonly as the Bull Moose party, was short-lived. It had former president Teddy Roosevelt heading its national ticket when their state convention met at the Arena on South Salina Street.

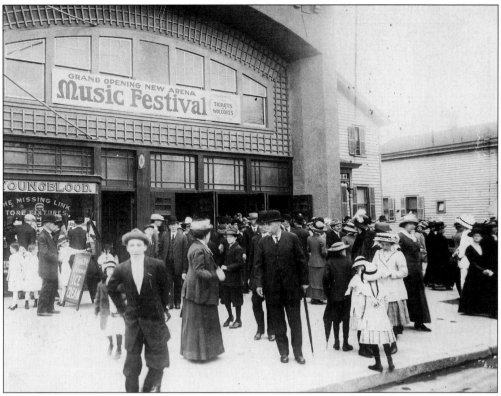

The Arena, c. 1910. This large assembly hall, located just south of downtown on South Salina Street, served many purposes over the years, hosting conventions, ice skating, hockey games, boxing matches, and concerts.

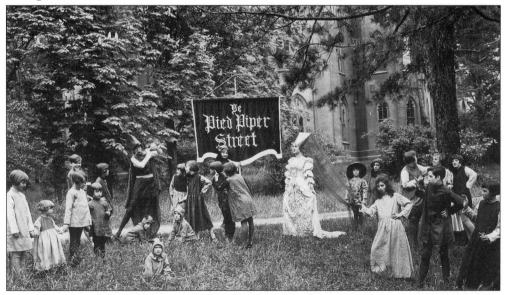

Local Theatrical Company, c. 1930. This apparently was a promotional photo for a production called *Ye Pied Piper Street*, an interpretation of the classic children's fable. The background is Yates Castle.

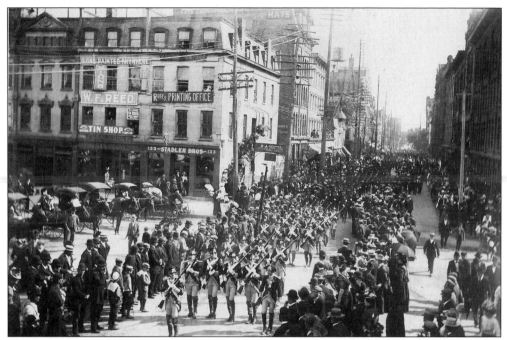

Parade on Clinton Street, c. 1900. This patriotic celebration could be a Fourth of July pageant. This parade is marching north on Clinton Street, just entering the west side of Clinton Square. Parades have been a consistent form of community celebration in both the nineteenth and twentieth centuries.

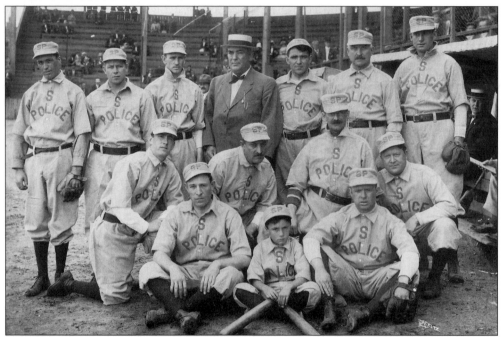

Syracuse Police Department Baseball Team, 1911. Cheering for a favorite team is a timeless experience. This rugged squad probably posed for this picture in Hallock Park, which stood north of Hiawatha Boulevard, just off Park Street, near the present Regional Market.

70

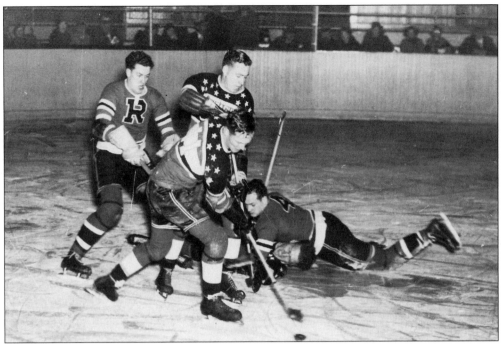

Syracuse Stars Hockey Game, 1930s. This scramble for the puck took place at the State Fair Coliseum. The Stars played here from 1930 until 1940. They won the first Calder Cup in 1936 as champions of the brand new American Hockey League.

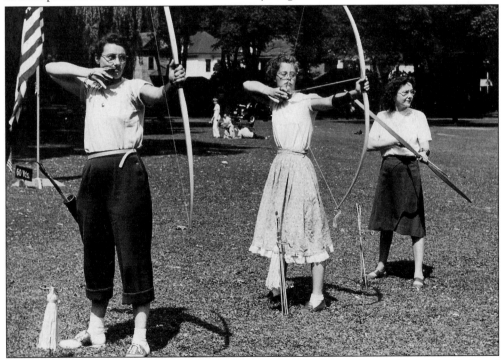

City Archery Tournament, 1955. This competition took place in Lower Onondaga Park and was won by Elizabeth Bates, the young woman shooting on the left.

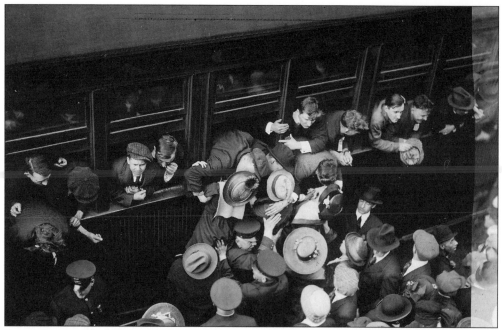

Departing for World War I, 1917. Like recruits in all wars, these future doughboys complete their emotional last goodbyes as their train leaves Syracuse for training camp.

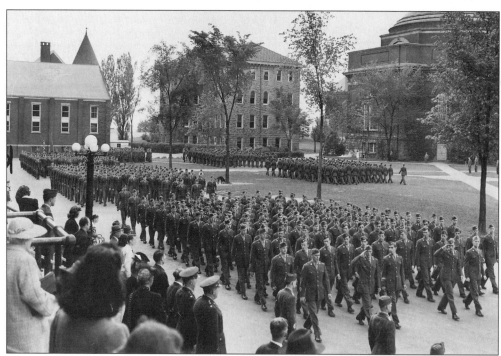

Syracuse University Campus, 1943. The military's presence in the lives of Syracusans was probably at its greatest during World War II.

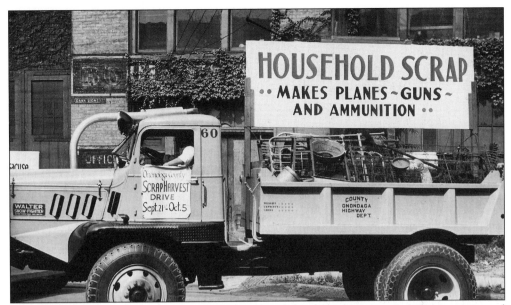

World War II Scrap Drive, 1942. This county truck has been set up to promote a scrap metal drive in the early years of the war. Like war rationing and air raid drills, these periodic campaigns were just one of the "home front" activities that allowed Syracuse area residents to support the war effort.

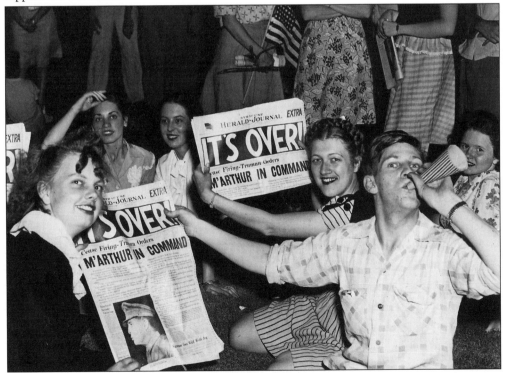

V-J Day, 1945. Like citizens in almost every American city on August 14 of that year, Syracusans celebrated the end of World War II with such an exuberance that it would remain one of the most emotional memories of an entire generation.

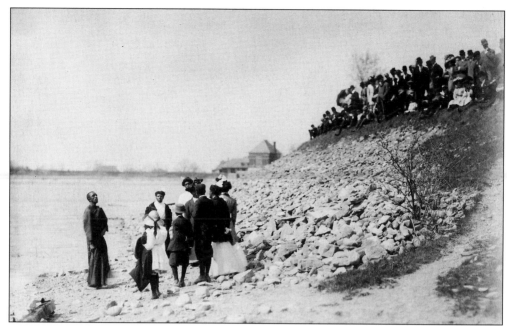

Baptism at Hiawatha Lake, 1911. This African-American congregation is seen conducting its religious ceremony in Upper Onondaga Park at the site of the city's former Wilkinson reservoir.

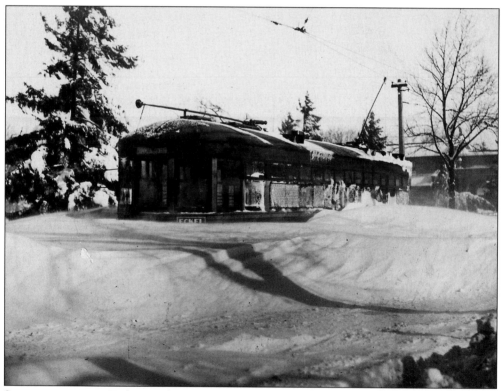

Snowstorm, 1932. To live in the Syracuse area has always meant the challenge of battling its winter snowstorms. In this case, a Court Street railway car has been temporarily defeated.

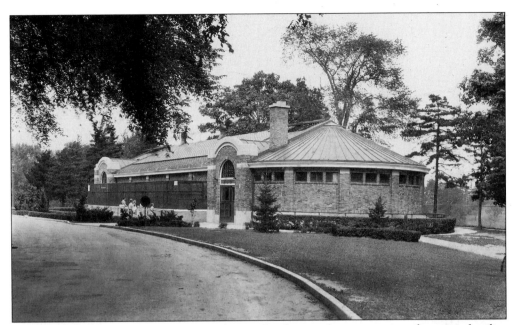

Burnet Park Zoo, c. 1945. Going to the zoo has been a favorite pastime for many families since it first opened in 1914. The *c.* 1930 main building (seen here) once housed most of the exotic animals.

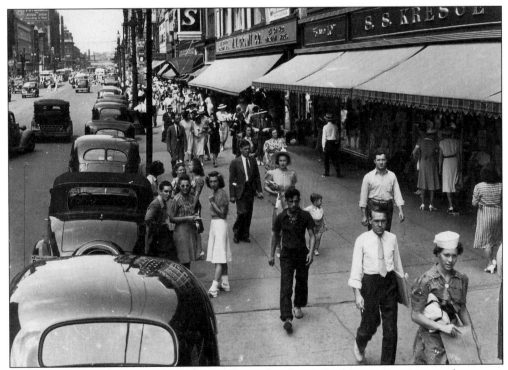

Downtown Shopping, c. 1940. Salina Street bustles with shoppers in an era when most women wore hats and dressed up to visit downtown. The teen-age girls sport the classic saddle shoes of the then-popular "bobby-soxer" look.

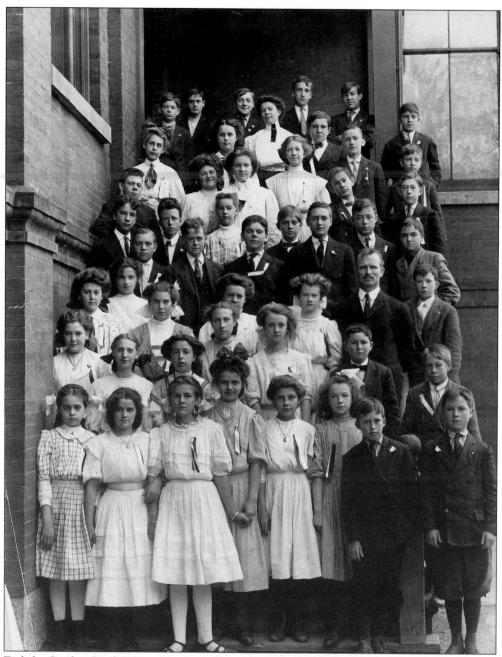

Eighth Grade Graduating Class of Prescott School, 1914. These fresh faces of the twentieth century eagerly await their future. Like all of us, their lives would be full of joys and sorrows, including, but not yet known to them, their confrontation with two world wars and the Great Depression.

Four
Defining Personalities:
Our Characters and Heroes

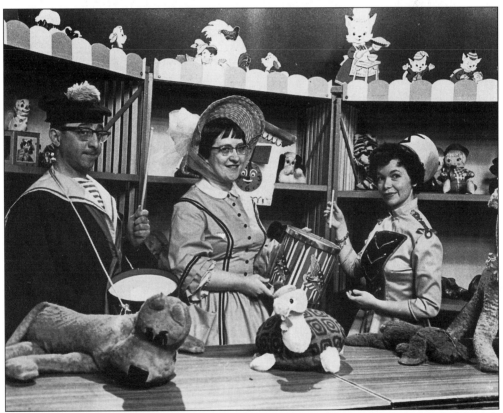

The Magic Toy Shop Cast, c. 1965. One of the earliest and longest running local children's television shows in the nation was produced in Syracuse from 1955 to 1982. The characters of Eddie Flum Num (Socrates Sampson), the Play Lady (Jean Daugherty), and Merrily (Marylin Hubbard Herr) became endearing friends to a generation and their children.

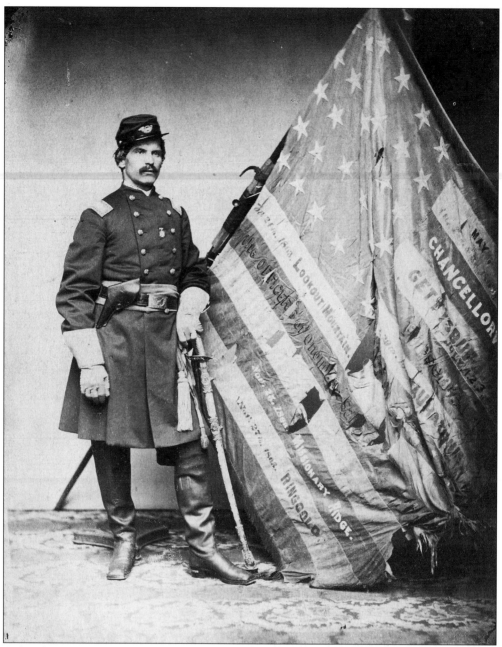

Colonel Henry A. Barnum, 1864. Barnum, an attorney by profession, rose to command the 149th New York Volunteers, the fourth regiment raised in Onondaga County during the Civil War. He poses with the unit's colors, proudly bearing the names of its battle actions. He died in 1892 and is buried in Oakwood Cemetery. The 149th fought valiantly at Gettysburg in 1863 and later marched with General Sherman through Georgia.

George N. Barnard, c. 1895. Barnard was one of Syracuse's most accomplished nineteenth-century photographers. He opened a daguerreotype studio in Syracuse in 1854 (see page 9) and built his reputation with a remarkable body of work documenting the Civil War. Barnard returned to Onondaga County late in life to live with family, and he died in 1902.

Agnes Amelia Dana, 1898. Born in Worcester, Massachusetts, in 1807, Agnes Amelia Livingston Johnson married Major Dana in 1833. He ran a grain and dry goods business in Hanover Square, and they resided, for a time, on James Street. She lived until 1901 and is buried with her husband in Oakwood Cemetery.

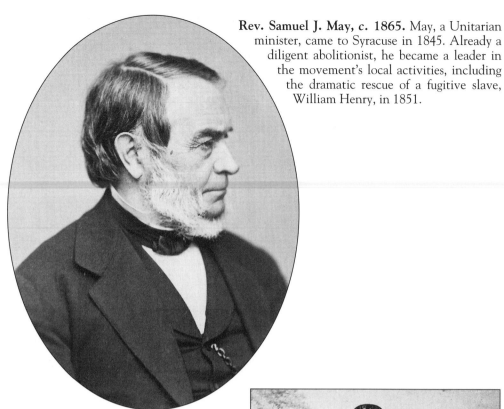

Rev. Samuel J. May, c. 1865. May, a Unitarian minister, came to Syracuse in 1845. Already a diligent abolitionist, he became a leader in the movement's local activities, including the dramatic rescue of a fugitive slave, William Henry, in 1851.

Helen Amelia Loguen Douglass, c. 1863. Helen's family was active in the abolitionist movement in Syracuse, where her father, Jermain Loguen, was pastor of AME Zion Church. In 1869, she married Frederick Douglass's son, Lewis.

Eugene W. Kellam, c. 1920. Kellam served as a Syracuse fireman for years, rising to the rank of lieutenant. In 1900, he twice performed heroic acts: first rescuing a fellow firefighter from a smoke-filled inferno and then saving a boy from drowning in the Oswego Canal.

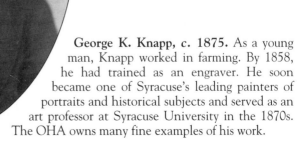

George K. Knapp, c. 1875. As a young man, Knapp worked in farming. By 1858, he had trained as an engraver. He soon became one of Syracuse's leading painters of portraits and historical subjects and served as an art professor at Syracuse University in the 1870s. The OHA owns many fine examples of his work.

Mary L. Wood, c. 1890. Wood lived with her family at 216 North West Street, a site now "buried" under the West Street arterial. She was born in 1869 and died relatively young, in 1909. Although little is known about Wood, she, like many others, is still a part of the rich tapestry that is Syracuse's past.

John G. Ciciarelli, c. 1912. Born in Italy in 1895, Ciciarelli came to America as a young child, settling in Syracuse. He eventually became prominent in the insurance business and the local Italian-American community. He helped lead the fund-raising campaign for erecting the downtown Christopher Columbus monument in the early 1930s.

Bernie Maurer, c. 1899. Maurer's first notoriety was as a pitcher for the Syracuse Stars in the early 1900s. He also raced ice boats on Onondaga Lake, not far from his family's Long Branch resort. Later, Maurer became a successful competitive bowler and was posthumously inducted into the Greater Syracuse Sports Hall of Fame in 1995.

Homer J. Wheaton, c. 1918. Wheaton had the distinction of being the first Syracusan killed overseas in World War I, sacrificing his life to protect comrades when a hand grenade was accidentally dropped. Posthumously awarded the Distinguished Service Cross, he also had a park named after him in 1941 on the city's east side.

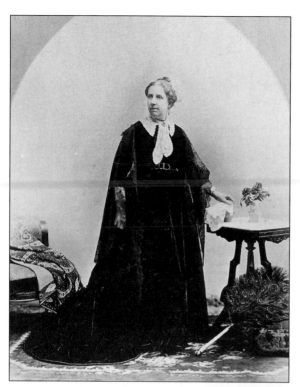

Margaret Tredwell Smith, c. 1885. The daughter of Lewis Redfield, one of the pioneer journalists of Onondaga County, Smith pursued many interests in her life. She wrote and lectured on zoology, Iroquois culture, and local history. She was a longtime member of the Onondaga Historical Association and presented the city with a memorial statue of her father. It was dedicated in Forman Park in May of 1908, just seven months before her death.

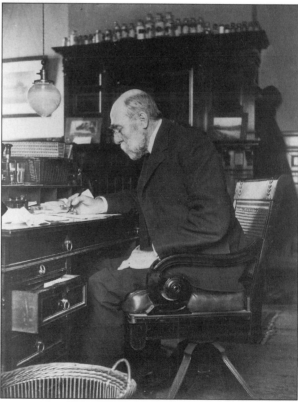

William B. Cogswell, c. 1910. Cogswell served as the chief engineer and general manager for the Solvay Process Company. The company's production method for making soda ash required strong concentrations of brine. Cogswell is credited with identifying the source of Syracuse's famous salt springs—the massive bed of rock salt that extends under the southern part of the county. The company used that source for over one hundred years.

Melville Clark, c. 1930. A Syracuse native, Clark ran the local Clark Music Company for over fifty years. Inventor of the Irish harp and an accomplished harpist, he played at the White House on seven different occasions. He succumbed to a heart attack at his store in 1953.

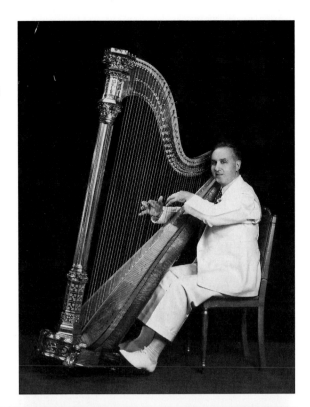

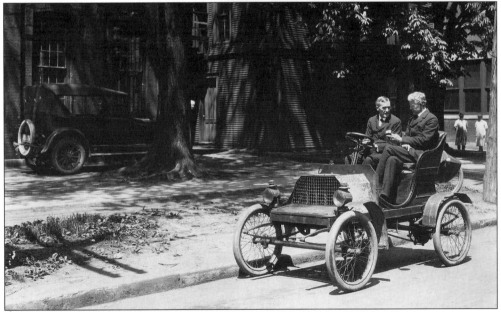

John Wilkinson, c. 1922. Wilkinson (right), the Franklin company's head engineer, poses here with S.G. Averill in the 1902 Franklin auto that was the first the company sold. Averill was its original owner and Wilkinson had designed it. The car is parked at 214 South Geddes Street, in front of the site where it was assembled. This innovative, four-cylinder, air-cooled auto is now owned by the Smithsonian.

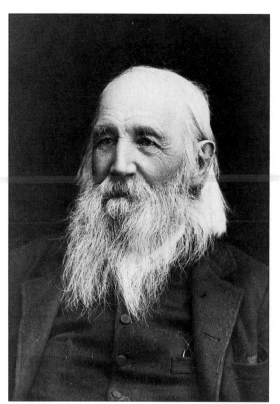

Thomas Gold Alvord, 1897. Alvord began practicing law in the village of Salina in 1833 and actively entered the salt business in 1844. He served in the New York State Assembly from 1844 to 1882 and as lieutenant governor in 1864. Alvord earned the nickname "Old Salt," partly for his looks, but mostly for his steadfast legislative work to protect local salt manufacturing interests.

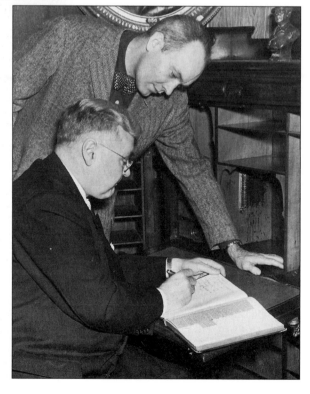

Richard N. Wright and Mayor Thomas Corcoran, 1951. One of the many treasures owned by the Onondaga Historical Association is a book containing the original signatures of every Syracuse mayor. Here, long-term OHA president Wright watches as Corcoran adds his name.

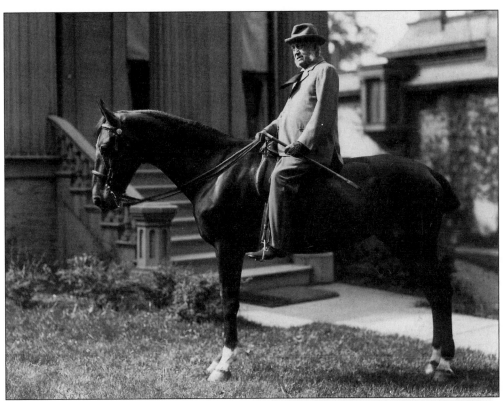

Charles Andrews, 1916. At the time of this photo, the ninety-year-old Andrews, an avid horseman, still personally used carriages instead of automobiles. A lawyer, Syracuse mayor in 1860, and later New York State Court of Appeals judge, he was instrumental in establishing Syracuse University in the city. Andrews lived in this home at 714 James Street.

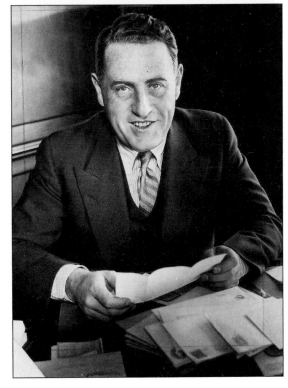

Mayor Rolland Marvin, c. 1950. Marvin was born in 1896 and rose quickly in politics to serve as Syracuse mayor from 1930 to 1941. He is credited with leading the struggle to relocate railroad tracks from the city's streets, helping bring Carrier Corporation to Syracuse, and insuring the 1934 birth of the professional Syracuse Chiefs baseball club by having MacArthur Stadium built.

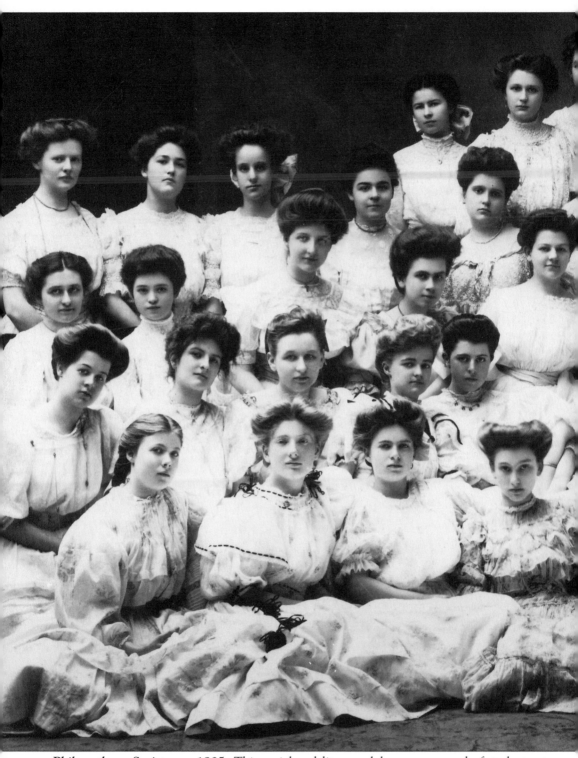

Philomathean Society, c. 1905. This social and literary club was composed of students at Central High School. Their weekly meetings included songs, poetry, the reading of original

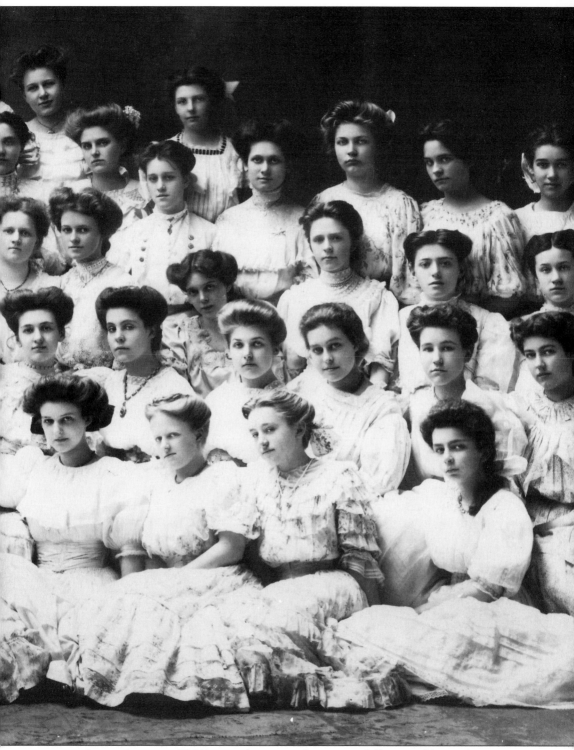

stories, and critical reviews. OHA's records contain the names of all pictured here, plus minutes of some meetings.

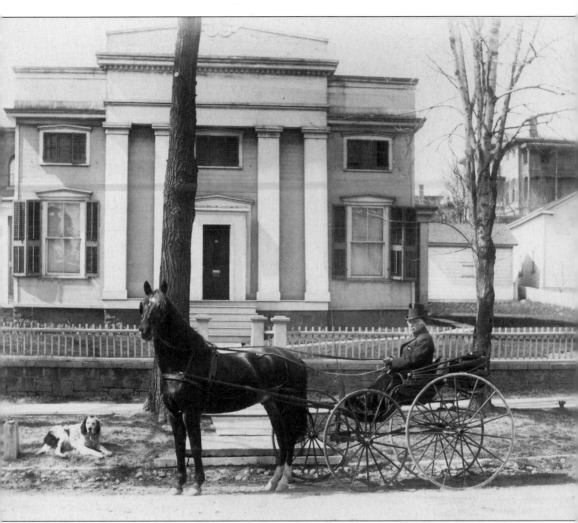

William Kirkpatrick, c. 1895. Kirkpatrick poses here at his 305 East Willow Street home. He held major business interests in the local salt industry and served on the Common Council in the 1850s. Upon his death in 1900, he left a large bequest to the Onondaga Historical Association, allowing the group to acquire its first permanent home at 311 Montgomery Street.

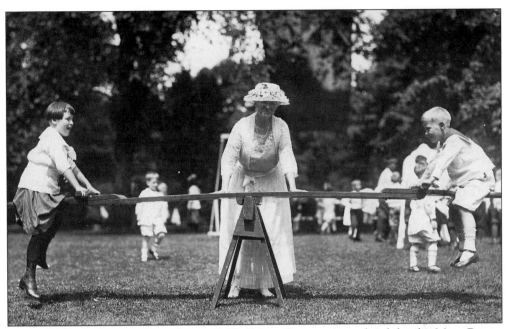

Mary Elizabeth Barnes Hiscock, c. 1915. Born of a prominent local family, Mary Barnes Hiscock was known as an outstanding leader both in civic activities and within the local social scene. Her father's house on James Street (today's Corinthian Club) eventually became her own family's home, where she hosted outings for area orphans (as pictured) as well as elegant social affairs.

Crandall Melvin Sr., c. 1950. Melvin ran the County's Emergency Work Bureau, which built Onondaga Lake Park in the early 1930s; in that capacity, he was especially influential in the creation of the Park's Salt Museum and original "French Fort" historic site. He was also Merchants National Bank president from 1938 until 1963 and a board member of the OHA.

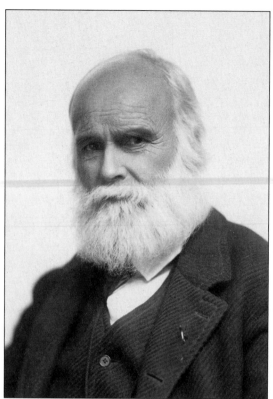

Amos L. Mason, c. 1895. Mason owned salt boiling blocks, but worked primarily as a contractor. He oversaw construction of Syracuse University's Hall of Languages, St. John the Baptist Church, the Dey Brothers building, almost 120 salt blocks, and nearly nine hundred other structures. He resided on Court Street.

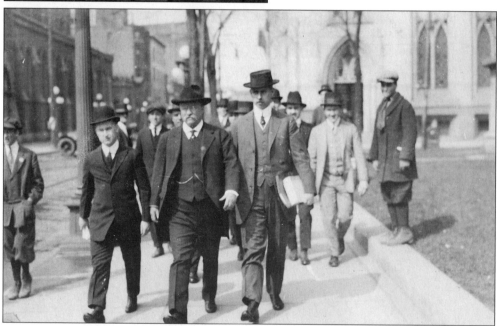

Theodore Roosevelt, 1915. Although not a native, in April of 1915 Roosevelt temporarily became Syracuse's most famous inhabitant. The Onondaga County Courthouse served as the site where Roosevelt successfully defended himself against a libel suit. Here he is seen walking along Jefferson Street, approaching the courthouse.

John Marsellus, c. 1940. Marsellus established the Marsellus Casket Company in 1872, today one of the city's oldest businesses and known throughout the nation as a leading manufacturer of fine wooden caskets. Besides his business acumen, Marsellus also published a book of prose and poetry in 1937.

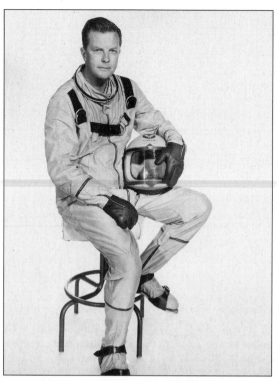

William Lundigan, c. 1959. "Bill" Lundigan grew up in Syracuse, attending old Nottingham High School and Syracuse University. By age sixteen, he was working as a radio announcer at WFBL's Hotel Onondaga studios; that led to a seventeen-year Hollywood movie career starting in 1937. He moved on to television and appears here costumed for his *Men Into Space* series. He died in 1975.

Jackie Coogan, 1923. This famous child actor of the silent-movie era co-starred with Charlie Chaplin in *The Kid*, and later played the character "Uncle Fester" in the 1960s *Addams Family* TV series. He had deep roots in Syracuse. His father was born here, and Coogan often stayed with his grandfather's family when visiting Syracuse. Coogan appears here in a publicity still from the film *Little Robinson Crusoe*. He died in 1984 at age sixty-nine.

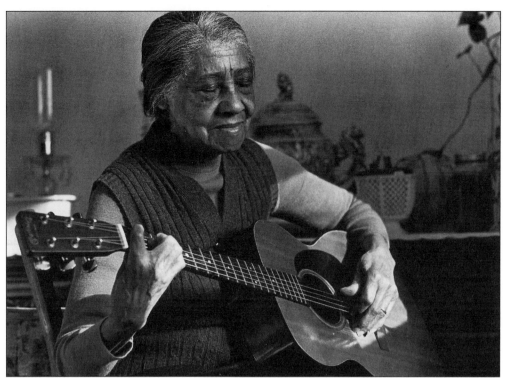

Libba Cotten, 1982. Grammy award-winner Elizabeth Cotten was a singer, composer, guitarist, and storyteller who moved to Syracuse in 1978 to be near family. Cotten was a self-taught folk musician whose most famous composition is the often-performed "Freight Train." She died in Syracuse in 1987 at age ninety-five. (Photograph by John Dowling.)

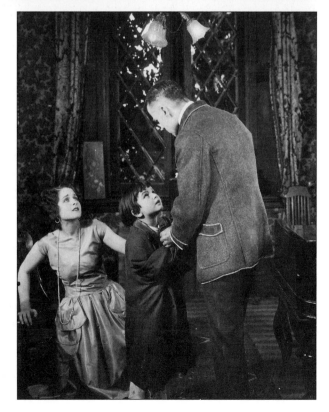

Norma Shearer, 1923. Shearer (left) appears here with Yvonne Logan and Richard Neil inside Syracuse's Calthrop mansion in a scene from the locally produced film, *A Clouded Name*. Shearer, recruited from New York, would subsequently use this film to launch a successful Hollywood motion picture career. OHA owns a rare, original promotional poster from this production.

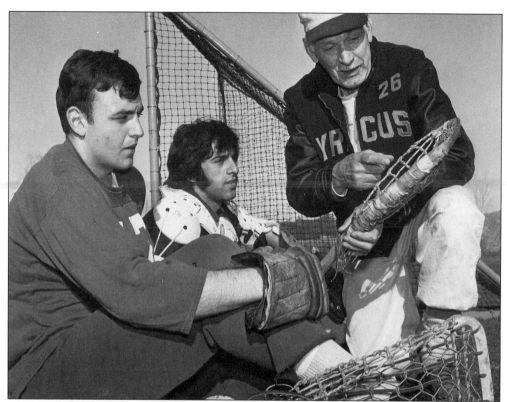

Roy Simmons Sr., c. 1970. Simmons made his career coaching various sports at Syracuse University, his alma mater, starting in 1925. He was most famous for turning the school into a national lacrosse powerhouse as its legendary coach from 1932 to 1970. He passed away in 1994.

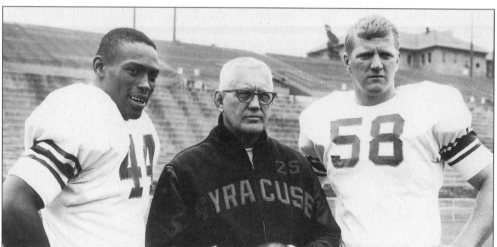

Floyd "Ben" Schwartzwalder, c. 1965. A Syracuse University football legend, Schwartzwalder coached on the Hill from 1949 through 1973. There were many great moments and victories, but none more memorable than the undefeated 1959 season followed by Syracuse's national championship win in the 1960 Cotton Bowl. Here he is seen between Floyd Little (left) and Pat Killorin (right). He remained in Syracuse after his retirement and died in 1993.

Five

Brine, Boats, and Boxcars:
Shaping Syracuse's Identity

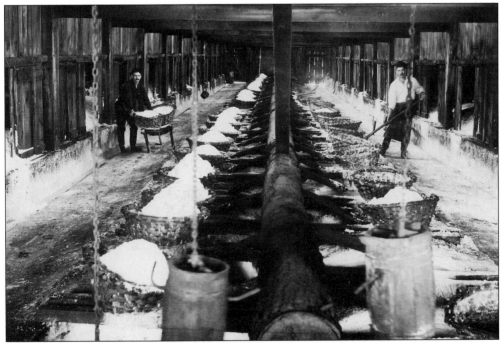

Salt Boiling Block Interior, c. 1880. In the Syracuse area, salt was always made by evaporating brine drawn from natural salt springs found near Onondaga Lake. Initially, the preferred production method was by boiling the brine down in large rows of kettles set in stone "blocks."

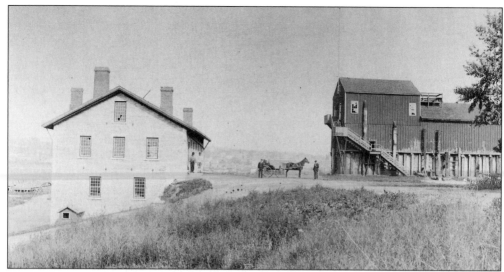

Syracuse District Pumphouse and Reservoir, c. 1895. This stone building at Spencer and Maltbie Streets housed a massive pump that forced brine up into the large, wood-enclosed cistern on the right. From this "reservoir," the salt water flowed by gravity through wood pipes to the surrounding evaporation fields and boiling blocks.

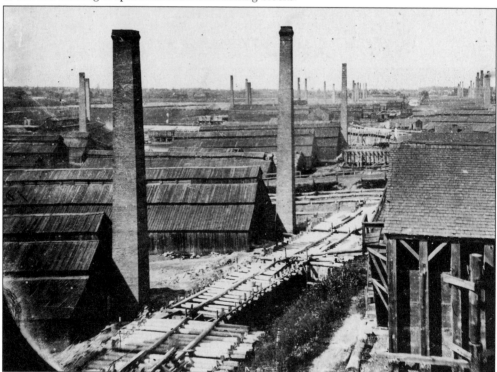

Salt Boiling Blocks, c. 1880. At one time, there were nearly three hundred of these salt "manufactories" stretching along the Oswego Canal, from Liverpool to Syracuse, and lining parts of the Erie Canal in Geddes. Those photographed here are in the area north of Hiawatha Boulevard. Such structures were so integral to the economic foundation of Syracuse, the "Salt City," that they are pictured on the official city seal.

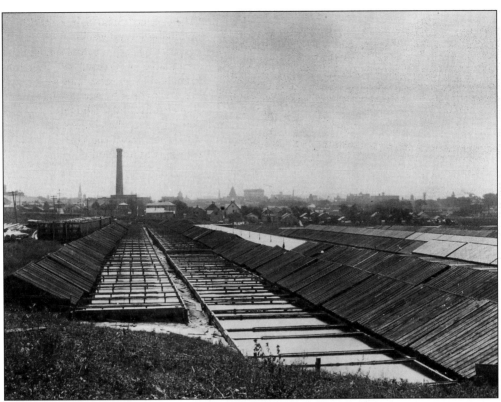

Solar Evaporation Sheds, c. 1895. In the nineteenth century, the area south of Onondaga Lake, between today's Route 690 and Interstate 81, was a distinctive Syracuse landscape formed by thousands of solar salt evaporating sheds. In the distance, looking south, one can discern the pyramidal tower of the Syracuse Savings Bank.

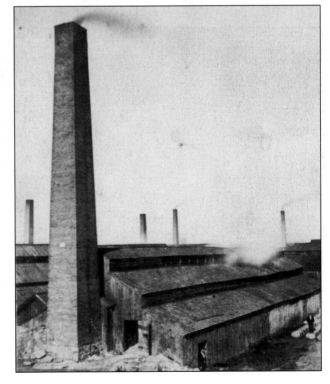

Salt Block, c. 1880. The salt blocks were initially fueled by huge quantities of wood, much of it from Oswego and northern Onondaga Counties. Later, Pennsylvania coal was employed and brought north by the Chenango Canal. Note the barrels of salt ready for shipping.

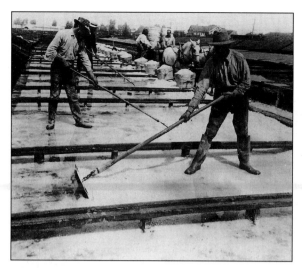

"Harvesting" Solar Salt, c. 1880. Following several weeks of evaporating action by the sun and wind, large, or "coarse," salt crystals formed in these vats. They were raked into piles by workers and shoveled into tubs. The tubs' contents were then dumped into horse-drawn carts for transport to warehouses.

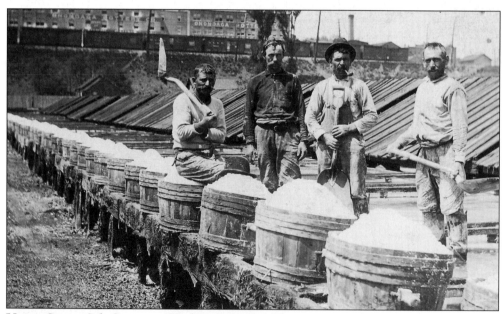

Union Coarse Salt Company Workers, c. 1900. These vats were located just north of West Genesee Street, across from today's Sacred Heart Church. In the background are buildings of the old Onondaga Pottery factory.

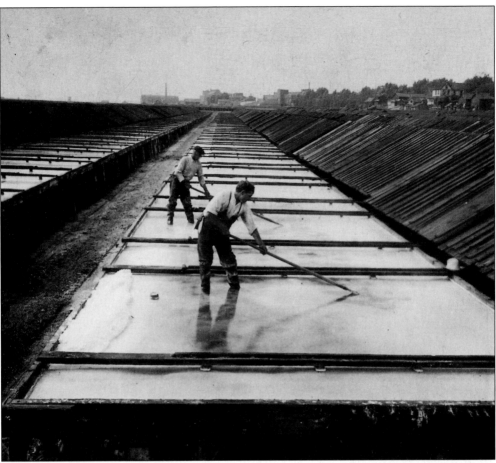

Solar Vats and Covers, c. 1878. Each worker stands in an individual vat. Each vat had a cover or shed that could be pushed on rollers to cover the brine in the event of rain. Nearly 50,000 such units blanketed the solar salt fields of Syracuse in the late nineteenth century. This was the production method that came to dominate the local industry after the 1870s. The last local production of salt was by this process in 1926.

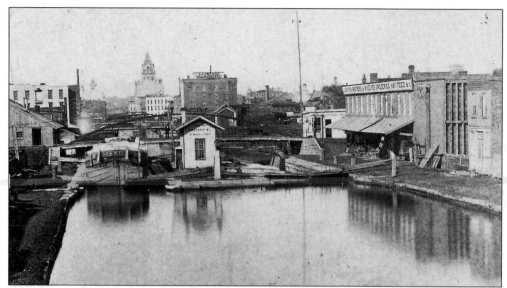

Lock 49, c. 1875. Here is the view one would have seen approaching downtown Syracuse in a canal boat traveling west. This lock was located just west of the Almond Street Bridge. The Gridley Building and Syracuse Savings Bank are visible in the distance.

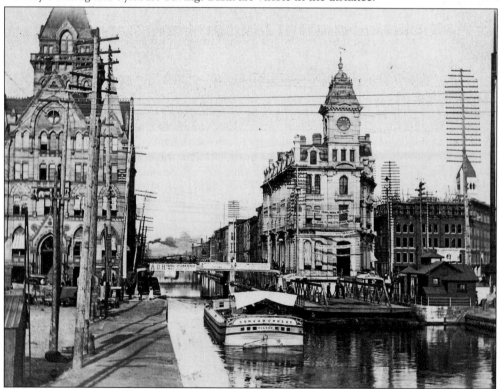

Clinton Square, 1892. This quintessential Syracuse scene was formed because the Erie Canal was engineered through the middle of what became the city's major civic space. Here a swing bridge carries Salina Street traffic over the waterway. Banners advertise different picnic outings for both the Hibernians and the Young Men's Republican Club.

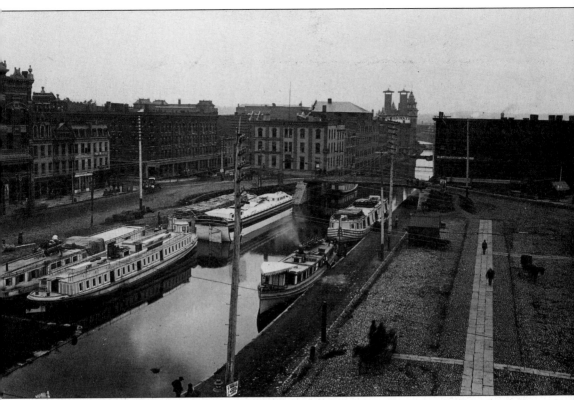

Clinton Square, Looking Southwest, c. 1890. Excursion boats and commercial barges vie for space in the widewaters area of Clinton Square. The large building at the extreme left is the Wieting Opera House. The space to the right of the canal was used as a farmers' market location. That spot later became the site for the 1910 construction of the Soldiers and Sailors Monument for Civil War veterans. Of all the structures visible here, the only one still standing today is the Amos Building (center), identified by its hipped roof.

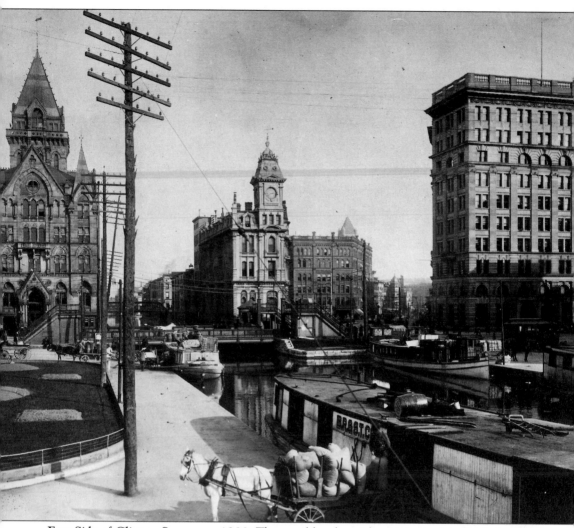

East Side of Clinton Square, c. 1900. The canal bustles with activity in this classic image of Syracuse at the very beginning of the twentieth century. By this date, the earlier Salina Street swing bridge had been replaced with a lift bridge. This "old" Erie Canal was replaced with the New York State Barge Canal by 1918. The latter utilizes the river system at the north end of Onondaga County. The Erie, a feature of Clinton Square for a century, was filled in during the 1920s.

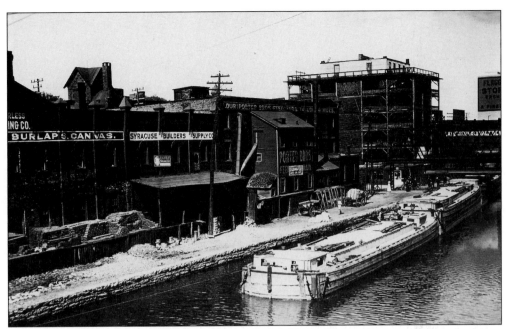

North Bank of the Erie Canal at State Street, 1916. This scene creates an excellent depiction of the fundamental, cargo hauling nature of the Erie Canal's presence in Syracuse.

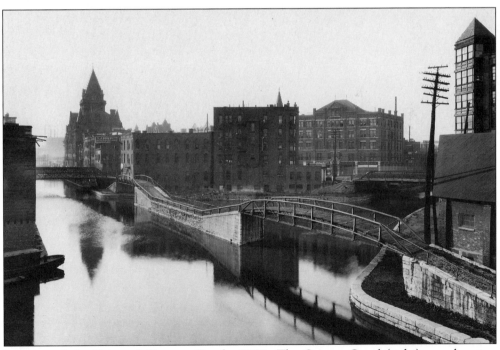

Junction of the Erie and Oswego Canals, 1921. The Oswego Canal (right) was almost as important to Syracuse as the Erie (left), but by this time both had been eclipsed by the recently opened State Barge Canal. Here the towpath and waters are quiet, awaiting the fate of both canals—to be filled in and converted to automobile boulevards.

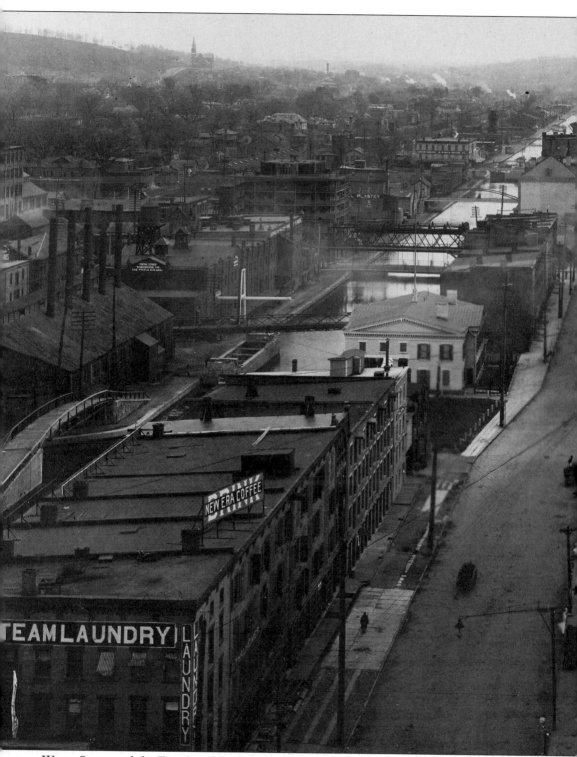

Water Street and the Erie Canal, Looking East, c. 1905. This remarkable photo conveys the somewhat gritty and not quite as romantic reality of how the canal had shaped the city's

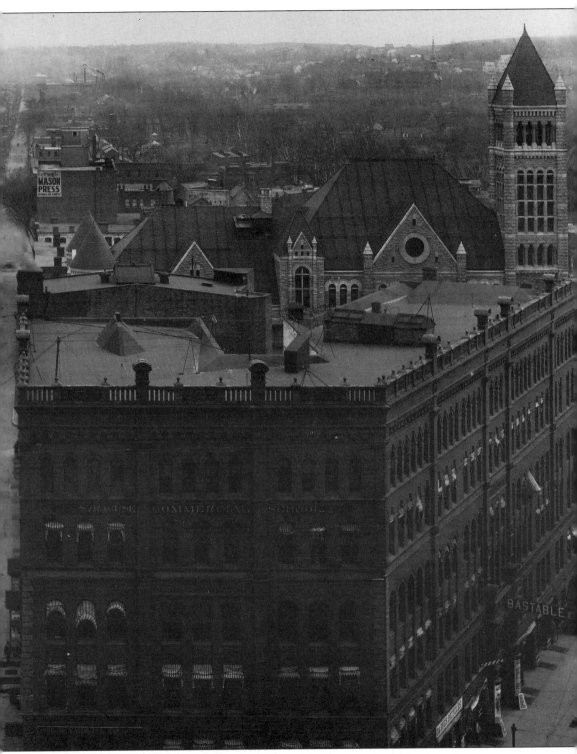

working districts that prospered along its path.

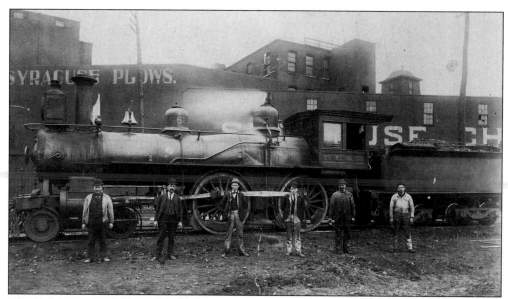

The Delaware, Lackawanna & Western Yards, c. 1900. In addition to salt works and canal boats, Syracuse's city seal also depicts a railroad train, another key to the city's economic growth and sense of identity. Here, a locomotive rests in the DL & W yards just northwest of Fayette and West Streets, with the factory of the Syracuse Chilled Plow Company in the background.

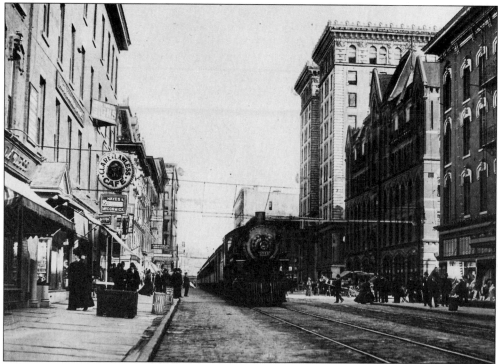

New York Central Westbound Crossing Salina Street, c. 1900. For nearly one hundred years, Syracuse had the dubious distinction and personality associated with the state's main east-west railroad route passing right through the middle of its downtown on Washington Street.

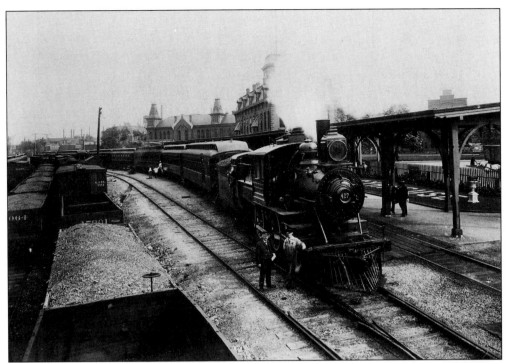

Delaware, Lackawanna & Western Railroad Station, c. 1898. The DL & W built this facility in 1877, and the station served the community for sixty-four years. It stood approximately where today's OnTrack station is located. In the background is the 1874 version of the New York State Armory.

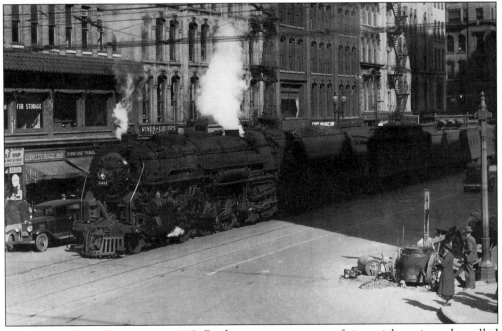

The Empire State Express, c. 1935. By this time, an average of sixty-eight trains a day rolled down Washington Street, stopping traffic at every north-south street that they crossed.

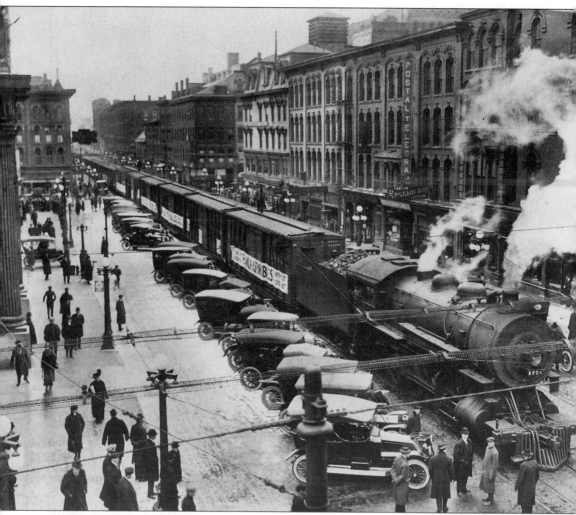

Freight Train in Vanderbilt Square, c. 1915. The banners on this east-bound freight proudly proclaim the contents of the boxcars as Syracuse-made Franklin automobiles. The columns of the University Building portico are visible on the extreme left. The Larned Building can be partly seen behind the engine's smoke. Various Franklin models are parked facing the train in this promotional event.

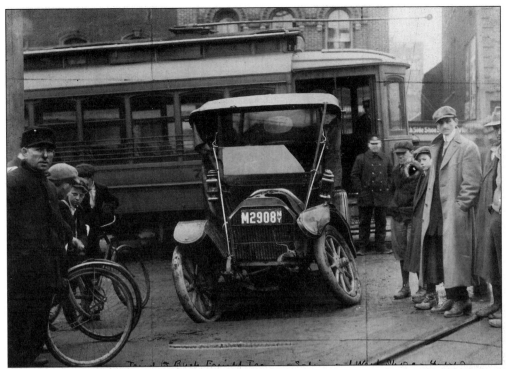

"Tried to Beat Freight Train," 1912. The original photograph carries this caption. It sums up the growing conflict on Syracuse streets as automobiles became increasingly more common.

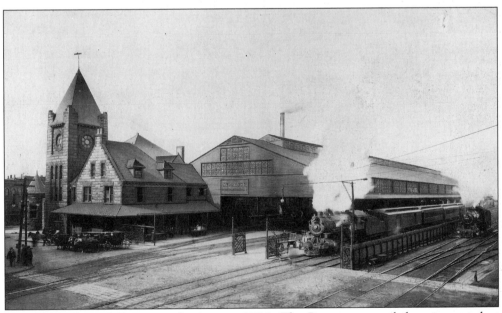

New York Central Passenger Station, c. 1900. The Romanesque-styled station stood at the northwest corner of West Fayette and South Franklin Streets from 1895 until 1939. The giant train shed extended west, bridging Onondaga Creek, and the tracks angled on to Washington Street.

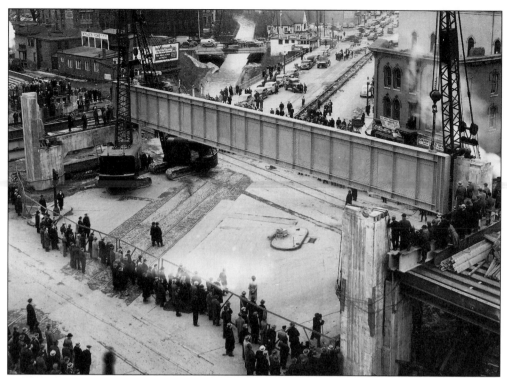

Constructing the DL & W Railroad Bridge Over West Onondaga Street, 1941. In the 1930s and 1940s, Syracuse finally elevated its mainline railroad tracks, reshaping the character of its urban landscape and giving the automobile singular control of the streets.

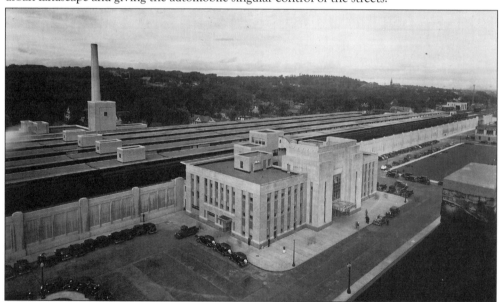

New York Central Passenger Station, 1936. The massive railway relocation project included construction of a new, Art Deco-styled station on Erie Boulevard. The automobile eventually required even more circulation space, and today, Route 690 has incorporated this elevated right of way.

Six
Lost Syracuse:
Landmarks to Remember

Crouse Mansion and "Stables," c. 1890. The northeast corner of Fayette and State Streets once contained the 1855 Italianate style mansion of John Crouse and the elaborate 1887 stables and amusement rooms built by his son, Daniel. Each was subsequently razed for New York Telephone facilities.

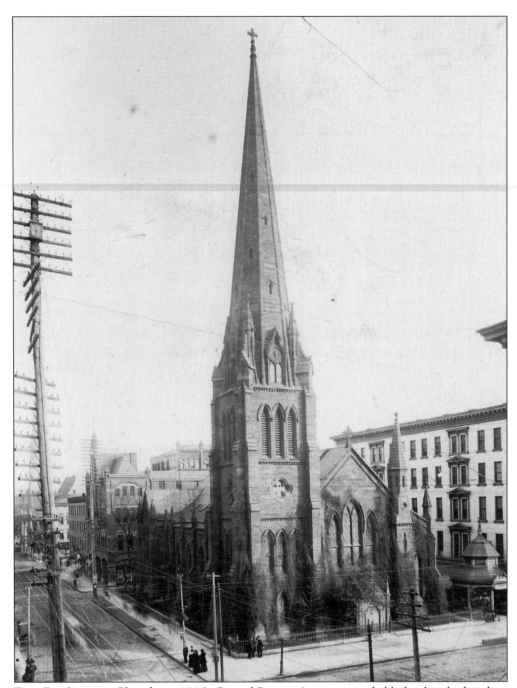

First Presbyterian Church, c. 1895. One of Syracuse's most remarkable landmark churches, this nineteenth-century brownstone edifice stood at the southeast corner of Salina and Fayette Streets. With its majestic 185-foot steeple, it dominated the city's main commercial street. It was dedicated in 1850 and demolished in 1905. The designer was Minard Lefever, a noted American architect of the day.

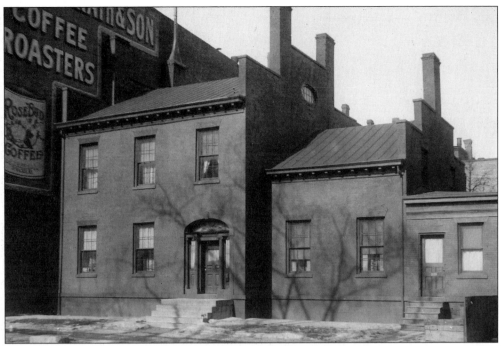

Numbers 210–212 West Willow Street, c. 1910. This Federal style structure was typical of the city's first generation of substantial middle- and upper-class homes, which were built throughout what is now downtown in the 1815 to 1845 period. What is noteworthy is how thoroughly they have all been eliminated.

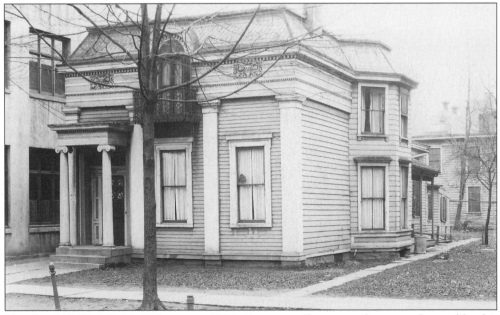

Number 705 East Genesee Street, c. 1930. Even a small nineteenth-century house, like this modified Greek Revival once located near Almond Street, could boast of some impressive details. These homes provided the urban vista with a texture, richness, and human scale that is often lacking today.

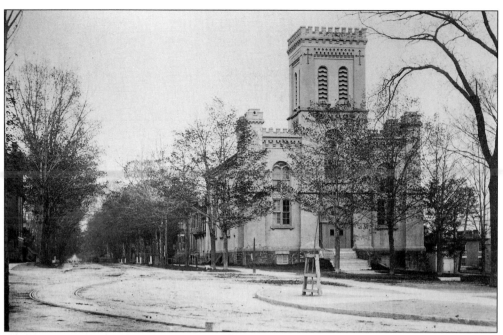

Unitarian Church of the Messiah, c. 1885. Finished in 1853 and considered Horatio N. White's first independent architectural commission in Syracuse, it stood at the southeast corner of Burnet and State Streets until demolished in the late 1960s. It is believed that this Romanesque Revival design reflected the influence of White's recent apprenticeship under James Renwick, architect of Yates Castle.

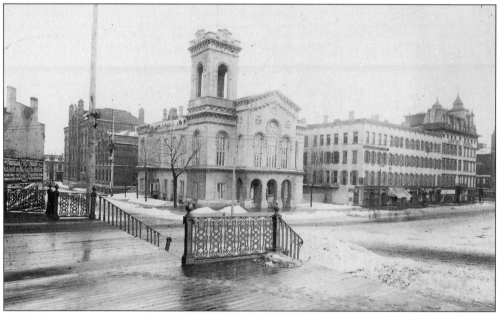

Third Onondaga County Courthouse, c. 1900. This Onondaga limestone edifice was built to the designs of Horatio N. White in 1856/57. It stood on the north side of Clinton Square until 1967. As one of the city's most prominent and distinctive landmarks, it was a symbol of Clinton Square's architectural maturity by the mid-nineteenth century as a major civic space.

Powell-Smith House, c. 1875.
This modest, but impressively proportioned Greek Revival home was built on the south side of West Genesee Street, facing Van Rensselaer Street. If standing today, it would rival many of the finest temple-form Greek Revival residences in New York State.

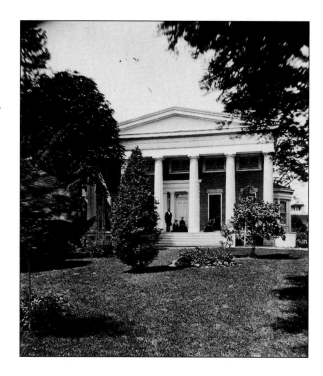

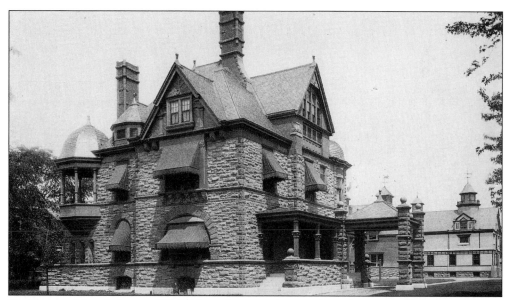

Residence of Jacob Amos, 1890. Many fine mansions, such as this one at 706 West Genesee Street, came to line portions of that route by the mid to late 1800s. By the 1920s, however, West Genesee was evolving into a commercial strip, increasingly dominated by automobile needs, so the houses were leveled. Amos was elected Syracuse's mayor in 1892 and 1894.

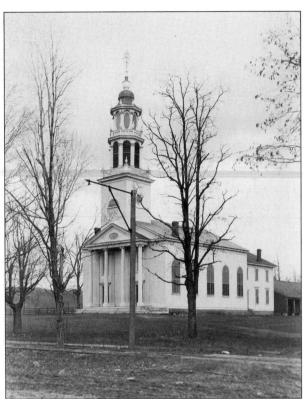

Valley Presbyterian Church, c. 1900. This superb example of the Federal architectural style illustrates the New England roots of many early settlers to Syracuse's Valley section. It was built in 1810 on the south side of West Seneca Turnpike, but then burned in 1922.

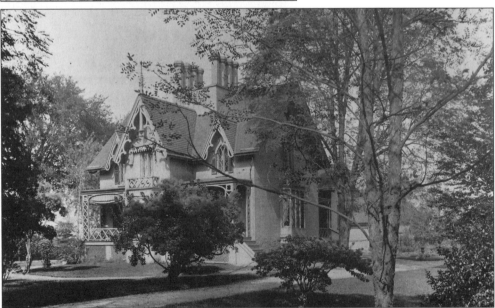

Wynkoop Home, c. 1900. It is hard to believe that this fine Gothic Revival home, built in the late 1840s, existed on the northeast corner of West Genesee and Geddes Streets, an area dominated today by fast-food outlets, gas stations, and automobile dealerships. Torn down in 1930, this structure is a poignant lesson in how cities grow and what we are willing to sacrifice in the process.

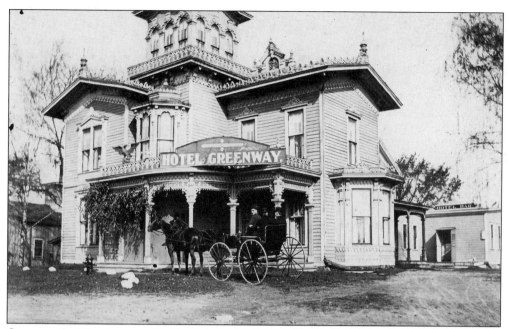

Greenway's Mansion, c. 1900. This building, which stood at the intersection of Grant Boulevard and James Street, is the epitome of Victorian woodwork detailing. Built in the 1860s as the home of local brewer John Greenway, it later became a tavern and 1920s "speakeasy" before being demolished.

Elks Building, c. 1944. Built around 1908, this neoclassical building stood on the east side of Clinton Street, between Water and Washington Streets. Although not one of the city's more distinguished landmarks, it demonstrates the richness and variety of urban architecture that Syracuse has lost.

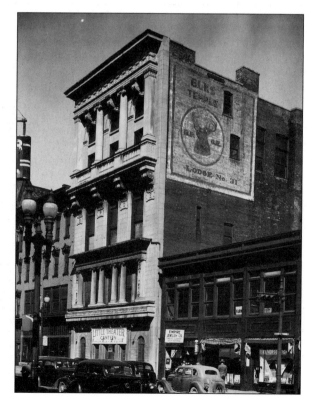

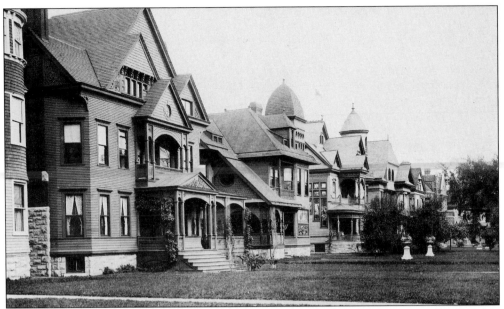

West Onondaga Street, 1894. Following West Genesee and James Streets, this thoroughfare became the third of Syracuse's mansion rows, although its lots were generally smaller. It remained the most intact of all three into the 1970s, but the community made no effort to protect it. Demolitions and alterations have continued, and the appeal of the architectural integrity seen here has been considerably weakened.

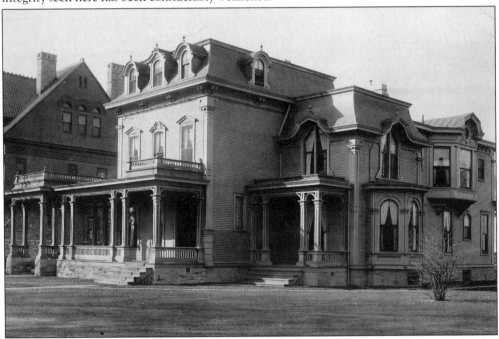

Francis Hendricks House, 1950. A fine residential example of the Second Empire style, this home was built in 1869 at 644 West Onondaga Street. It was torn down about 1950 for a new apartment building. Hendricks was president of the Trust and Deposit Company of Onondaga until 1913 and also served as a New York state senator.

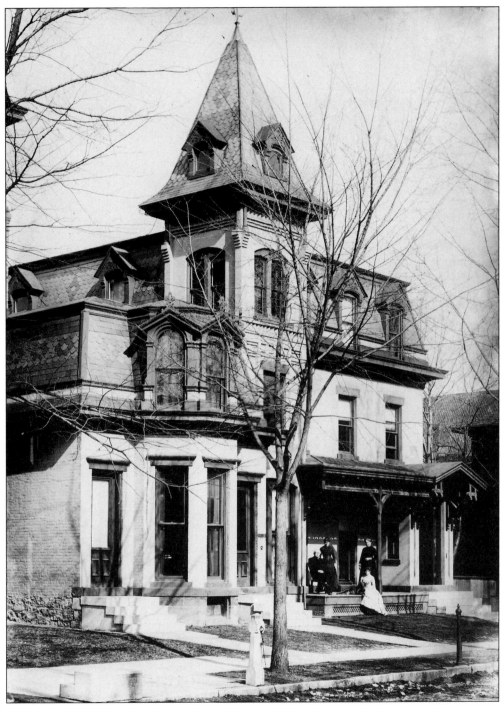

Pease Home at 320–322 Montgomery Street, c. 1880. This is a good example of the middle-class residential character found throughout the last half of the nineteenth century in much of what is now downtown. The smaller addition with the bay window was added in 1874 and served as Dr. Pease's office. The family poses here on their porch. The house was razed in the early twentieth century for a Masonic Temple.

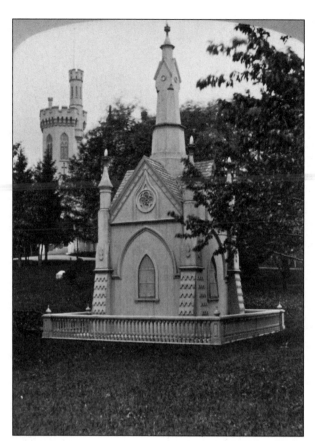

Chapel, Yates Castle Grounds, c. 1875. The main house was impressive enough, but the grounds of this estate included an array of fanciful Victorian outbuildings and landscape features. This Gothic-styled chapel bears a striking resemblance to an 1866 mausoleum in nearby Oakwood cemetery.

Yates Castle, c. 1875. This 1852 Gothic Revival edifice was one of the most architecturally significant residences ever built in Syracuse. The architect was James Renwick, who also designed the Smithsonian's first building in Washington. After serving as home to the Longstreet and Yates families, it was acquired by Syracuse University. It was ultimately demolished by New York State in 1953 for an addition to its local medical school.

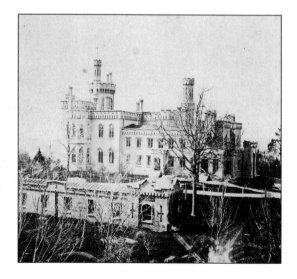

Greenhouse, Yates Castle Grounds, c. 1875. The Gothic style was carried over to this rather compact conservatory. The Yates estate was located just west of the intersection of Irving and Waverly Avenues. A portion of its perimeter stone wall is all that remains.

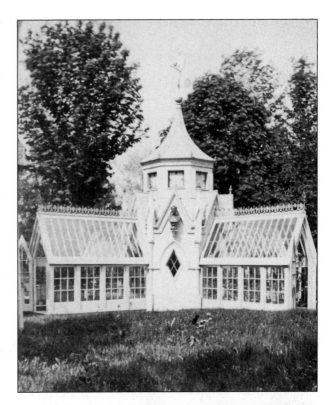

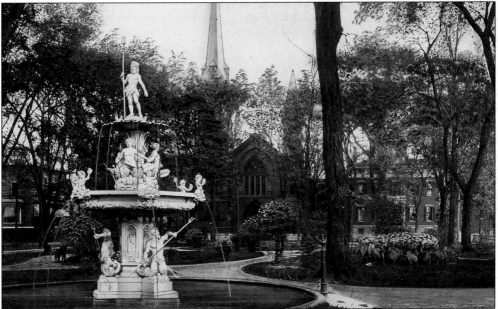

Fayette Park, Looking East, c. 1900. Fayette Park was once ringed with the homes of wealthy people. This lush, romantic scene reflects a major landscaping project that took place around 1870, in what had been a small green space dating from Syracuse's days as a village. The cast-iron fountain, featuring Neptune and his trident, was installed in 1871 as a $1,500 gift from neighbor John Crouse. It has since been removed.

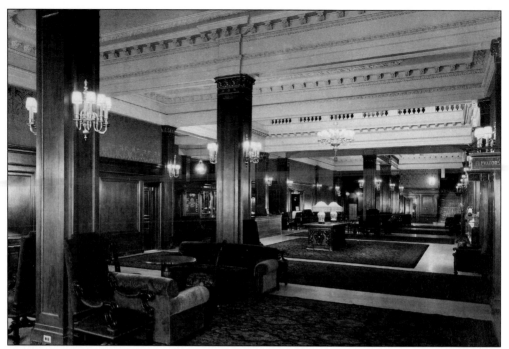

Hotel Onondaga Lobby, c. 1920. Opened in 1910, the Onondaga stood at the northwest corner of Jefferson and Warren Streets. With five hundred rooms, a famous roof garden dining room, and this elegant lobby, it was one of the city's premier hotels. The Onondaga was demolished in 1970 and replaced with an office building.

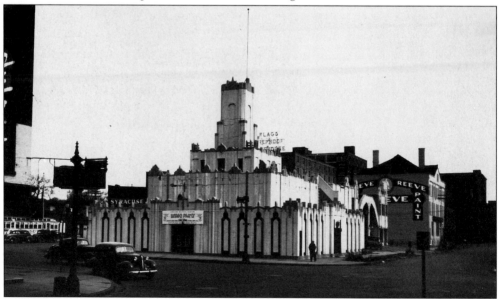

Cafe Dewitt, c. 1937. This unusual Art Deco nightclub at Erie Boulevard and State Street was one of the many, but often unsuccessful, projects of Julian Brown, son of local industrialist Alexander Brown. He spent a fortune building this establishment, shortly after the start of the Great Depression, and it is referred to as "Brown's Folly." A financial failure, it was demolished in 1939, and a gas station was built on the site.

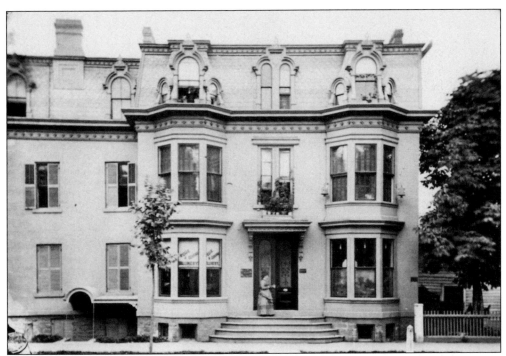

Southwest Corner of Jefferson and Warren Streets, 1876. Known as Martin's Block, this Second Empire style structure housed residential spaces and a modest millinery shop. It reflects a lost past, a time when some downtown streets led a much more genteel life than today.

Number 714 James Street, c. 1930. This is good example of the pre-Civil War period homes that once lined lower James Street. This Greek Revival style home also reveals some rarer Egyptian Revival detailing in the lotus leaf capitals topping its columns. It was built c. 1851 for Thomas T. Davis, a salt manufacturer.

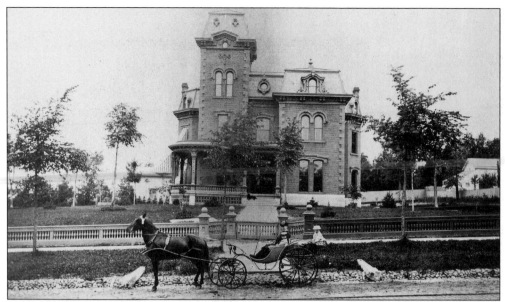

Number 831 James Street, c. 1870. This great Second Empire style mansion was built about 1869 for the family of Horace K. White. The architect was Horatio Nelson White (not related), who had also recently designed the Gridley Building. James Street continued its role as the city's leading avenue of wealthy residences throughout the nineteenth century.

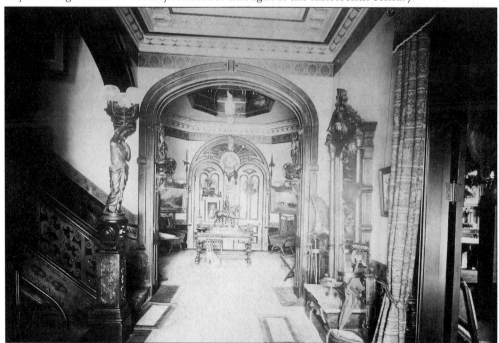

Number 831 James Street, Interior, c. 1875. This view demonstrates the tastefully cluttered look of most upper-class, late-Victorian homes. The hall mirror is a good example of the then-popular Renaissance Revival style in furniture. Horace K. White, the owner, was a banker and salt manufacturer. His son, Horace, who grew up here, served briefly as governor of New York in 1910.

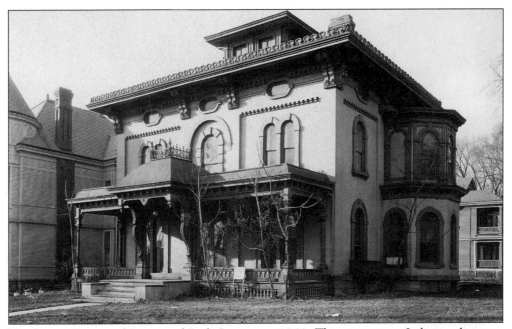

Northwest Corner of James and Lodi Streets, c. 1940. This picturesque Italianate home at 769 James Street is believed to have been built around the time of the Civil War by Gershon Kenyon, a banker. Its use later shifted to apartments in the twentieth century. It was torn down by 1953 and replaced with the large Skyline Apartments.

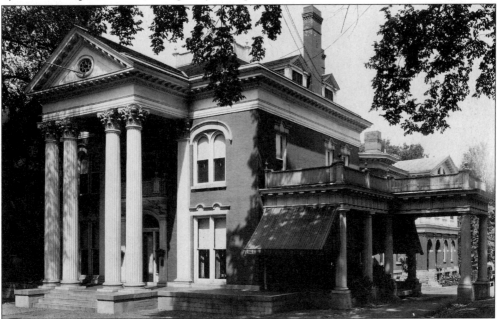

D.M. Edwards Estate, c. 1940. This imposing mansion stood at 953 James Street. Built in 1865, its original form was simpler. In 1905, prominent local retailer D.M. Edwards acquired the house and expanded it with rear additions and a massive Georgian Revival portico. In 1946, it was purchased by the nascent LeMoyne College as a residence for its Jesuit faculty. They left by 1958, and it was demolished in 1960.

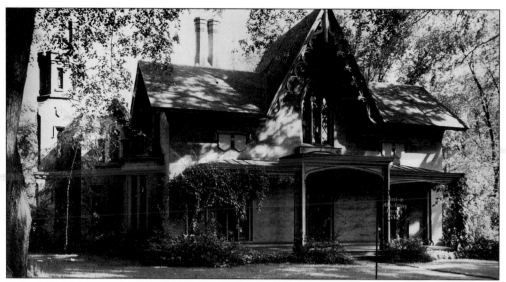

Sedgwick Cottage, c. 1958. This splendid Gothic Revival home was designed in 1845 by Alexander Jackson Davis, considered one of America's most important nineteenth-century architects. It stood at 742 James as the home of Charles Sedgwick. The post-World War II transformation of James Street from a premier residential avenue to a busy commercial district remains an irreplaceable loss to many Syracusans.

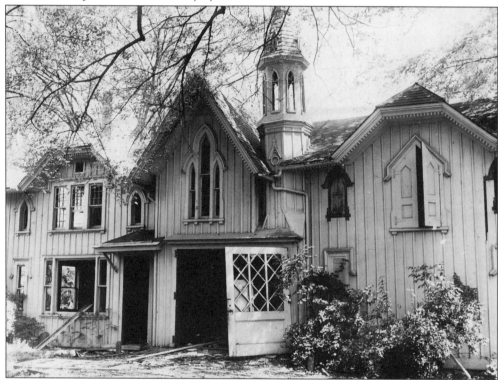

Sedgwick Cottage Service Building, 1962. Despite bearing the scars of neglect and vandalism on the eve of its demolition, even this carriage house still illustrated the attention to detail that another age valued.